THE QUICKEST WAY TO PAINT WELL

THE QUICKEST WAY
TO
PAINT WELL

A MANUAL FOR THE PART-TIME PAINTER

By

FREDERIC TAUBES

STUDIO PUBLICATIONS, INC.

In Association with

THOMAS Y. CROWELL COMPANY
NEW YORK AND LONDON

Technical Photographs by William Zeller

Paintings by the author reproduced by courtesy of
Associated American Artists Galleries

Copyright, 1950
THE STUDIO PUBLICATIONS, INC.

Printed in U.S.A.

CONTENTS

FOREWORD

Many nonprofessional people have asked me to write a concise and compact exposition of fine craftsmanship in painting for those who would follow it as a serious discipline but who for one reason or another cannot give it their full time. I have written a number of books of diverse character and it would seem that one of them should have met this problem—specifically, that of the limited-time painter. For it is the serious part-time painter who is forever searching for a method of utmost simplicity and directness in rendition.

The problems of the part-time painter are of a somewhat different nature from those treated in my former books. He may be a commercial artist, a professional or business man; at any rate, he is hard at work five days a week trying to make a living. He is, perhaps, physically incapable of spending considerable avocational time in giving himself to thorough investigations or preparations in matters of technique; he dreads exercises of any kind once his daily chores are done. If he is a commercial artist he will most likely have a good grounding in draftsmanship and, with or without this useful training, he probably has a well-cultivated taste and an understanding of things artistic.

For this man, therefore, and for any intelligent layman, I have endeavored in the present volume to reduce the process of painting to such essentials as will enable him to produce paintings commensurate with his talent and creditable in point of technique.

In my experience over many years with literally thousands of pupils, I have frequently found that an innate talent has often been buried under a frustrating incapacity to handle materials in such fashion as to bring about adequate results. On the other hand, I have had numerous outstanding cases where people who had spent half their lives in sundry occupations often entirely foreign to art have, after a relatively short period of instruction, become capable of producing estimable canvases. I can go so far as to say that I have often found such work to surpass the products of many a recognized professional.

The task of creating an art-course concentrate, so to speak—a manual to guide the part-time painter—has not been particularly easy, for the only method I could recommend, regardless of the person for whom designed, would have been fully approved in the traditional workshops of the past. The problem has been to simplify some complex procedures without the sacrifice of any essential elements and to develop a method that would serve the student and guide him to the achievement of fine craftsmanship. I hope that my aim has here been realized.

CHAPTER I
MATERIALS

TO GET STARTED

The succeeding chapters discuss in detail the equipment, materials, and practice of oil painting but here, to start with (talent aside) is an "at-a-glance" list of your requirements.*

1. Space and suitable light for work. North light is ideal as sun must not interfere. Daylight fluorescent lamps are recommended for supplementary light or for evening work.
2. Easel
3. Brushes (see Chapter II)
4. Colors (see Chapter IV). Also white lead oil paint in can for priming (see page 16)
5. Wooden palette, oil cup
6. Palette knives (see Chapter II)
7. Canvases (see page 13)
8. Charcoal and fixatives
9. Painting media (see Chapter III)
10. Varnishes, diluents (including linseed oil, turpentine), see pages 16, 17, 55, Chapter III, cobalt drier, page 29
11. Soap or soap flakes and rags for cleaning brushes
12. Frames (see Chapter IX)

No matter what your manner of painting may be (or what you desire it to be if you are just beginning) nor in what direction your aesthetic leanings may tend, perfect familiarity with the artist's tools and materials is imperative. For the knowledge or ignorance of the nature of these materials may spell the difference between success or failure of your efforts.

Since this book has been designed for the "part-time" painter—the amateur, the student as well as practicing artists in other fields—the narrowest range of materials has been chosen, but their limitation is only in number, not in kind. Hence, this limitation does not imply that the technique which they allow will be limited.

From the foregoing it appears that success or failure in picture making need not necessarily be attributed to the nature of our talent alone. With the same amount of talent one can produce creditable or inferior works, all depending on one's familiarity with the paint

* The resume of the book on page 92 may be helpful as a step-by-step guide of procedures.

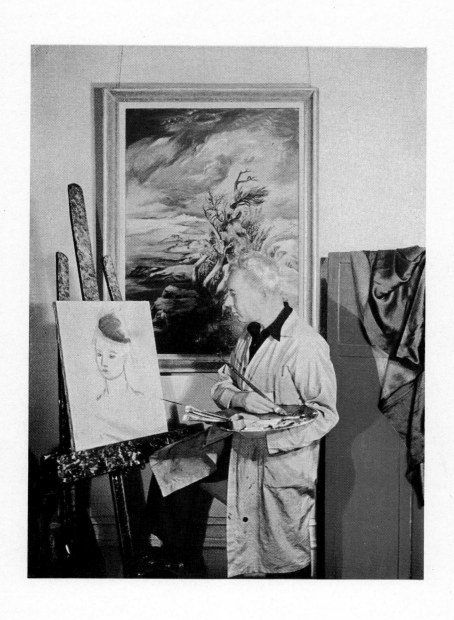

FREDERIC TAUBES in his studio.

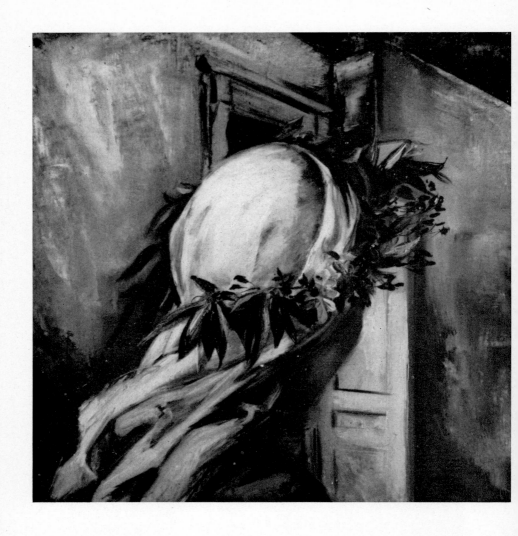

EXPECTATION. A painting done at one sitting (alla prima) on an ochre-white toned ground. See page 15 for the preparation of a toned canvas ground.

Opposite page: BATHERS. Another alla prima painting on an ochre-white toned ground.

10

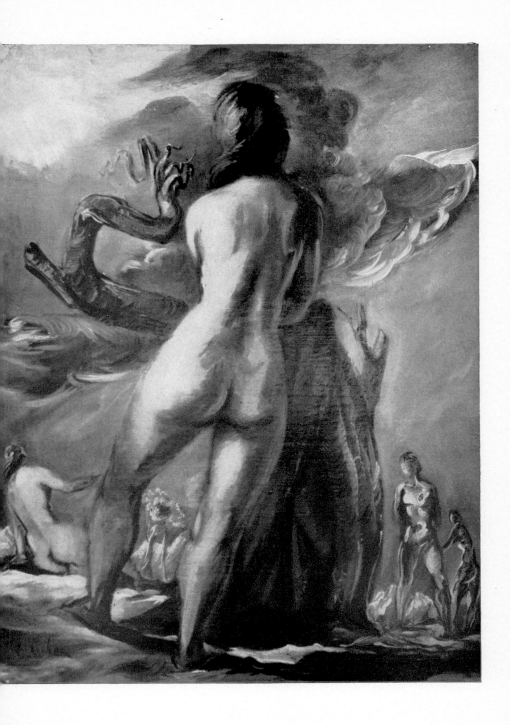

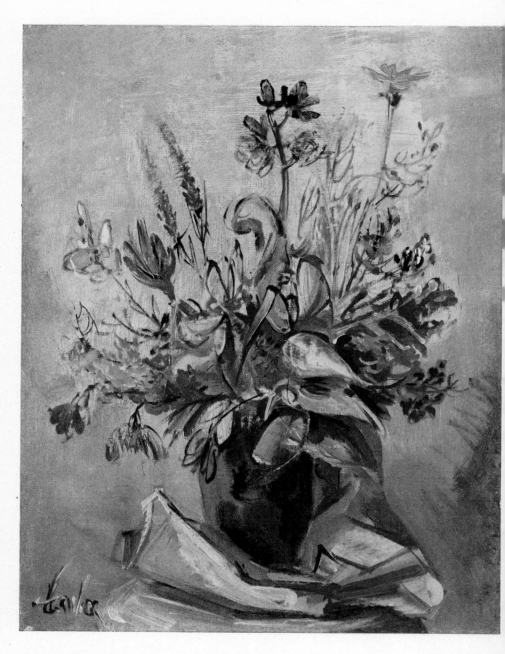

FLOWERS. This painting was completed in a few hours. The canvas carried a
light gray toned ground with multicolored imprimatura.

technique. Not only the palpable, material qualities but even such an imponderability as the imagination will be affected in some measure by knowledge or ignorance in regard to paint techniques.

CANVASES

It has been my experience that one of the main difficulties painters encounter is in the selection of a proper canvas. When painting thinly, a poor canvas will unavoidably nullify the painter's best efforts. Hence good results cannot be obtained when painting thinly or with only a moderate impasto* on an unpleasantly textured canvas.

Poor canvases. What, then, are the characteristics of a poor canvas? (1) Rigidity. This condition prevails when the canvas is glued to a stiff support, cardboard as a rule. (2) Roughly grained, single-primed cotton canvas. (Single-primed means that only one layer of priming— a white, inert pigment bound, usually, with synthetic resin—has been applied to the support.) (3) Canvas made of synthetic or glass fiber. Such fabrics have absolute uniformity of grain which gives them a forbiddingly monotonous appearance. (4) The rough side of Masonite board. The screen pattern impressed upon it is extremely tedious to look at. No matter how heavily a priming (or paint) is put on top of it, the pattern will always remain visible. Of course I refer to a reasonably thick paint stratum, for a heavily troweled-on paint will cover up the deficiency of any support. (5) Canvas made of a coarse material, whether of purest linen fiber or a crude jute.

To repeat, a coarse canvas grain can be very well covered up by successive overpaints. However, we shall deal in this book with painting processes which do not involve prolonged preliminary labors.

Suitable canvases. In discussing canvases in this book, it is taken for granted that they have already been stretched, sized, and have had one coat of priming when bought in a shop. Most canvases are sold this way.

(1) *Medium-fine cotton or linen fabrics.* The former will always be mechanically even, which does not contribute to the textural charm of any painting, but one single application of a toned ground or priming (described on page 15) will, as a rule, take care of this, for you create a texture of your own with this layer of paint. Linen is also sometimes uniform in texture; it may have a variable, moderately uneven grain, or it may show knots in the weave. In my opinion, a moderately uneven appearance of the fabric offers the most pleasing sensations to the eye.

* Thickness of colors layed on.

(2) *The smooth side of a Masonite panel.* This support, also known as Presdwood, is favored by many painters. It is not, however, my choice because its rigidity is not conducive to the use of the palette knife. The preparation or priming, as we call it, of the Masonite panel is described on page 16.

(3) *Cardboard or paper.* Where absolute permanence is not a matter of concern, a cardboard, or one of the heavier grades of paper, can be used as a surface for painting. (A pure rag paper, however, can be considered a permanent material.) Whether cardboard or paper, special preparation is required to make them suitable for receiving paint. The priming of cardboard and paper is described on page 17.

To visualize the surface appearance of the support, I have demonstrated the characteristics of various fabrics in figures *a, b, c, d.*

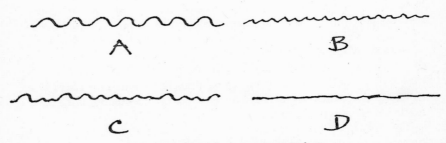

Characteristics of various canvas surfaces.

(*a*) The illustration shows the surface of an over-bumpy canvas. It is unsuitable for alla prima painting*, for the crevices in the canvas take too much paint to allow articulation in one or two operations. Only a number of successive paint layers preceding the final painting would permit the painter to express himself freely.

(*b*) Represented in this illustration is a fine, sharp-toothed canvas which is excellent for alla prima painting, especially when first sandpapered (use sandpaper No. oo but don't smooth the canvas down too much). It is still recommended, however, to cover this with a priming or toned ground as described later.

* A complete painting done at one sitting.

(c) This drawing represents, in my opinion, the ideal linen. Its thread is slightly irregular and although it is often designated as a double-primed material, nevertheless it will, as a rule, require an additional priming or toned ground to be just right.

(d) Shown here is the practically toothless—at least to the naked eye—surface of a primed panel. For alla prima painting such a surface is most suitable. But there are degrees of smoothness, and too slick a priming of a panel would offer many disadvantages. For instance, an oversmooth surface may not only impair the adhesion of paint to the ground but it may also impart to the finished painting a disagreeable slickness. By experimentation, you will find out what I mean.

As for Masonite, cardboard, or paper supports, it is best to prepare them oneself as instructed on pages 16 and 17. The operation is easy to carry out with small risk of failure however inexperienced you may be.

PRIMING CANVASES

Although the canvases we have been discussing have already been stretched, sized, and primed at the time purchased, an additional priming is always beneficial. This priming can be white, or it can be colored. As will be seen from the color illustrations on pages 46 and 47, neither the head nor the figures were painted on the white canvas ground. The canvas used for painting the head carries a gray-brownish tone, and the figures, in addition to a pink priming, carry an application of a very thinly and *transparently* spread color over the priming. This thin color film is referred to as *imprimatura*. It is discussed on page 61.

In contrast to the imprimatura which is thin and transparent, the *color* priming of solid opaque paint is known as *toned ground*. For all-round purposes, raw umber mixed with flake white (or white lead oil paint, mentioned in the next paragraph) is best for toned ground in the painting of portraits and figures. It is not so suitable for flower and landscape painting. The reason is obvious. Whereas portraits and figures show a limited range of colors and can be painted in a rather closely knit tonality, floral and landscape subject matter calls for plain white priming or higher-keyed and more diverse colors than those used as a base for portraits and figures— yellow, for instance (see pages 64 and 70). A darker ground, in the degree of its distance from white, will obviously have a tendency to lower the key of the painting and produce a subdued tonality, providing that only one paint layer rests on top of it. Heavy overpaints would, of course, nullify this characteristic of a dark toned ground.

THE PREPARATION FOR PRIMING OR TONED GROUND

A toned ground mixed in the following way serves, of course, the same function as a plain white priming, with the additional effects described above. A quantity of white lead oil paint (house paint) of the grade sold in cans (I find Dutch Boy brand best) is mixed by means of a palette knife with enough raw umber oil color to suggest a tonality such as can be seen in the color plate on page 47. (For plain white priming leave out the tint.) This gray-brownish paint is then thinned with Copal Varnish to the consistency of extra-heavy cream and spread with a not too elastic palette knife onto the stretched canvas until it is evenly covered. Apply it thinly. The ground can be used for painting in about a week, as the umber is a very fast-drying color. Let the canvas dry in a light and airy place. Don't expose directly to the sun, or hide it away in a cupboard or closet. N.B. The flake white suggested as a mixture with the raw umber in the second paragraph on Priming Canvases is a substitute for the Dutch Boy white lead oil paint. Being a finer preparation of the same basic substance, it can, of course, be used instead of the latter. For economy's sake, however, the latter is preferable and equally good for purposes of priming. For painting proper, flake white from the tube should of course be used.

Umber is not the only color, however, to be used for a toned ground. It can also be a light pink. The pink color should be produced from flake white (or white lead oil paint from a can, as described previously) and venetian red or light red and *not* from cadmium or indian red which, with white, produce unpleasant purplish nuances. The priming can also be gray (prussian blue, umber, and white) or yellowish (ochre and white). Lately I, personally, have come to consider the umber-white color in slightly darker or lighter variations as best. (The color background in the portrait on page 47 can be considered as rather dark. Darker shades than this are impractical in alla prima painting.)

PREPARING A MASONITE PANEL

The simplest way is as follows: white paint should be thinned with Copal Varnish to the consistency of light cream. In contrast to the priming material used on canvas, the paint used for priming a panel should be liquid or, at best, semiliquid. It should be applied to the panel with a large brush that has long and elastic bristles. The reason the priming should be so greatly reduced with the varnish is to let it spread over the surface of the panel without leaving brush marks. The presence of brush marks can be very disturbing when attempting to paint on the panel. A palette knife is not suitable for

laying a priming onto a rigid surface. Thinning the priming paint with turpentine instead of varnish is also inadvisable since there is no binding power in this solvent, nor is there the requisite capacity for adhering sufficiently well to the support. Retouching varnish or damar picture varnish can be used, but the Copal Varnish must be considered superior for this specific use.

When only one thin priming is used, the brown color of the panel will show through the semitransparent white paint, thus producing what we may call a middle tone. One can paint directly on this middle tone or apply a second and third priming to render it opaquely white. The several primings can be done on consecutive days, and painting can proceed a few days later when the priming is quite dry.

When painting on a panel, the gray-brown ground such as is used on a canvas seems to me to be undesirable. A simple imprimatura (described on page 61) is much more sympathetic to the nature and character of a panel.

THE PREPARATION OF CARDBOARD

Whether gray, brown, or white, cardboard must be prepared in a different manner. Cardboard is sufficiently porous to absorb oil or varnish from the paint paste, thus rendering the paint brittle. To prevent this loss of the binder, sizing of the board should be carried out prior to the priming.

The simplest way to size cardboard is to brush onto it a commercial shellac solution thinned with alcohol (shellac thinner, methanol) to one-third of its volume. Cardboard prepared in this manner need not be primed, that is, painting can proceed on the shellac-sized surface. Besides shellac, gelatine or glue can be used for sizing in the proportion of one ounce of gelatine (technical grade, or the quality used for cooking) to one pint of water. A porous material will require a stronger concentration of glue.

THE PREPARATION OF PAPER

When using paper (only the heavy or medium-heavy weight is suitable) a light gelatine sizing—one ounce of gelatine to 30-50 ounces of water—will make the paper sufficiently nonabsorbent for oil painting. A definite quantity of gelatine cannot be determined in advance, because this depends on the manner in which the paper was sized in the process of manufacturing. On a standard illustration board, for example, a 1:50* solution will, as a rule, be appropriate.

* One ounce of gelatine to 50 ounces of water.

The paper should be fairly smooth. The pebbly, water-color quality paper, and the hard, slick, cold-pressed variety are not very well adapted for oil painting.

TO SUM UP

A canvas is chosen from the types described in this chapter. The canvas has already been stretched, sized, and primed in the store. (In the case of Masonite panel, cardboard, or paper, the priming should be done at home.) An additional priming of the canvas is desirable in the form of either a plain white or a toned ground, the latter being recommended for most work in one or another tint. This priming is prepared from white lead oil paint (in a can) or flake white from a tube, thinned with Copal Varnish. The required tint is added. The color of this priming is opaque.

For certain paintings an imprimatura base may be used. The primary difference between this and a toned ground is that it is of a semitransparent color. That is, an oil color without the admixture of white, thinned with Copal Varnish to the consistency of water color, whereas a toned ground is opaque and always mixed with white. Furthermore, being thin, it does not change the surface texture of the canvas which the priming does. It should, therefore, be used over a priming of white. See page 61 for further discussions about imprimatura.

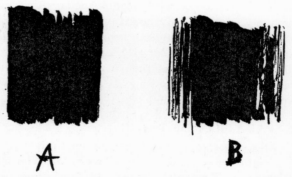

Contours produced by various bristle brushes (see opposite).

CHAPTER II
TOOLS FOR PAINTING

BRUSHES

One can surely develop a penchant for tools and, like the author, accumulate a collection of brushes and knives running actually into hundreds of items. This is not to say that technical proficiency will be increased in the least by an arsenal of this kind at one's disposal. In fact, all the tools necessary for unhampered work (two knives and nine brushes) will be seen reproduced on pages 21, 22, and 23. Four of these brushes should be made of bristles and their size should conform to the specifications given under the illustrations. The remaining five brushes should be made of soft hair—four of them of sable, or the less expensive but still excellent fitch hair. The last brush in this group is made of squirrel hair, and we shall refer to it hereafter as the soft-hair blender. The actual size of these brushes as well as the painting knives is shown by the photographs which are to scale.

Bristle brushes should always be used at the start, where an energetic tool is needed. The length of the bristles is important. Overlong bristles which look so elegant and expensive have too much spring, hence they are rather useless at the start of work when one wishes to transfer, with a minimum of effort, as much paint as needed from the palette to the canvas. The same, of course, is true of sable brushes. Shorter bristles are far better for performing this task. The palette knife, too, will be found a very useful instrument for distribution of large quantities of paint.

Now it has been said on many occasions that the well-constructed brush should have the bristles at both ends of the ferrule turned toward the middle. Such a brush will produce a contour like that indicated in illustration (a)*. Whether this type of contour is desired or that in illustration (b) is purely a matter of personal preference.

The contour in (b) was made by a brush of inferior quality and poor construction. Here the bristles are somewhat spread and this condition becomes more pronounced when the bristles are moist with paint. However, this circumstance will produce soft, blurred contours and pictorial effects which the perfect brush will not render.

* See opposite page.

A brush does not really become useless when it starts to spread, for this can be remedied by tying up the bristles as shown below,

Reconditioning of a brush after it has started to spread.

but when the bristles become brittle or start to fall out, then it is no longer any good. Sable hair, especially, when old will show this tendency.

Flat and round sable brushes are indispensable for delicate work where it is not desired to show much impasto (thickness of colors layed on) or deeply impressed brush strokes. Painters who are interested in painting fine, minute details will require smaller, flat sable brushes than those reproduced on pages 22 and 23. Some painters, by the nature of their work, rely exclusively on sable brushes. If the support is smooth, like that of a panel, paper, or extra-fine linen, this is entirely practicable. By experimentation you will arrive at your own preferences.

A small, round, pointed sable brush is used for producing fine delineaments and details, hence the hair of this brush should always terminate in a fine point. To preserve the sharp point on such a brush, it is necessary, after every washing, to bring the hairs together with the lips and permit them to dry, all the hairs pressed to one point.

A large sable brush is also quite important in painting, for it permits strong, quick delineaments as well as a variety of effects which cannot be produced by any other brush. It is good to have a brush with a perfect point, but a large sable brush with a fuzzy tip also has certain merits in painting.

The top larger brush reproduced on page 23 is the soft-hair blender. The hair of this brush is too weak to do anything more to a layer of paint than to fuse gently the very top stratum of colors. Of course the sable brush is an efficient blender, too, but certain delicate color transitions can be produced only by means of the soft-hair blender.

I shall not go into detail here about the care and reconditioning of brushes, as this subject has been dealt with extensively in my other books. However, the essential must be repeated, and it is sufficient to say that turpentine, the old stand-by, is *not* a proper agent

Two palette knives required for work. The drawing at the right shows the trowel-shaped knife not recommended. The second knife has been tapered to permit more delicate operation.

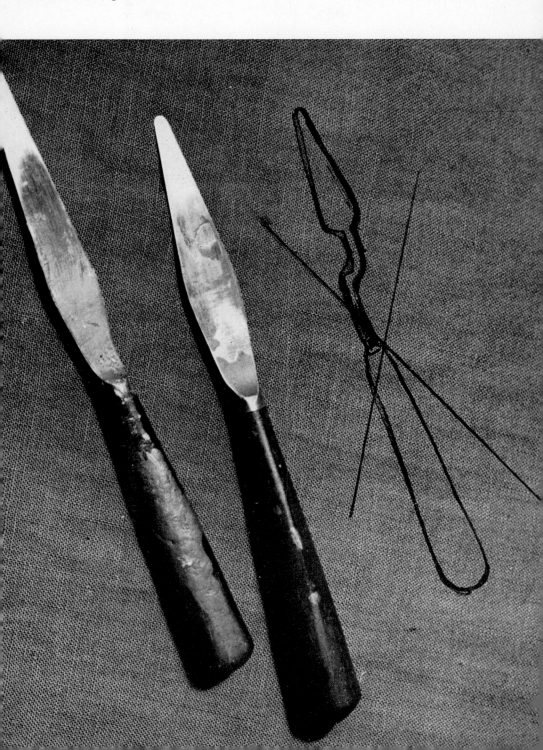

On these two pages are a complete set of brushes recommended for use. The illustrations show actual size of brushes. On this page are the bristle brushes in sizes 5, 6, 8, 10 (left to right).

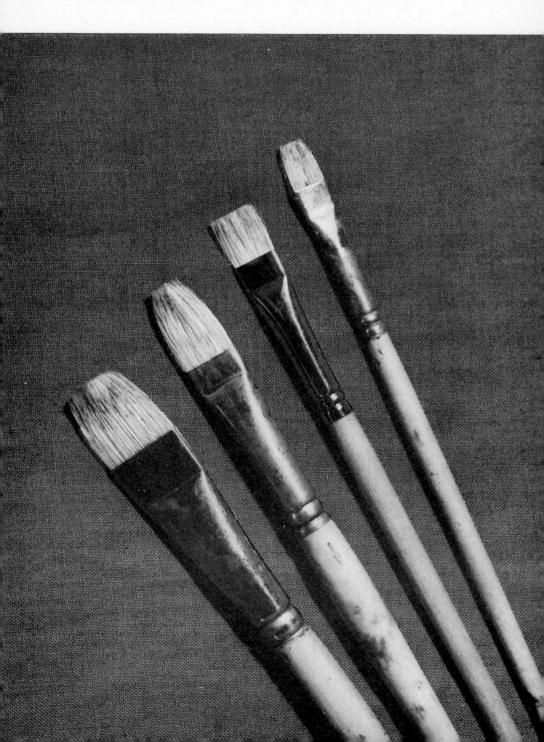

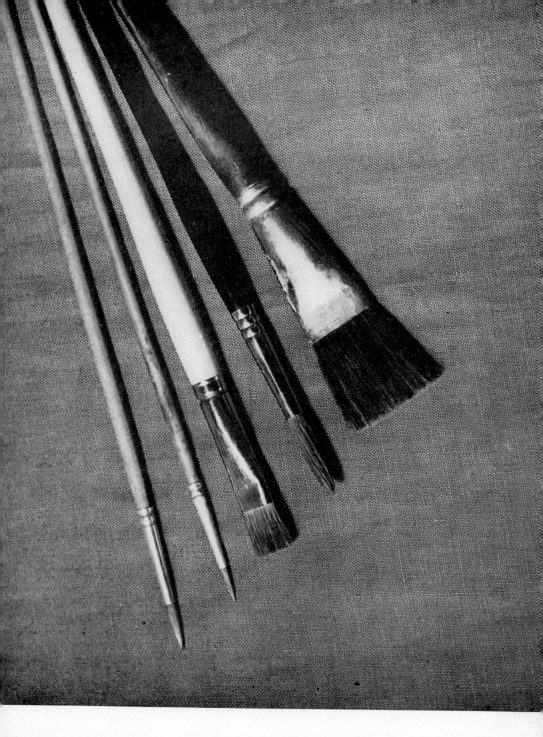

On this page (from left to right) are the sable brushes—round, flat and, at top right, the soft-hair blender.

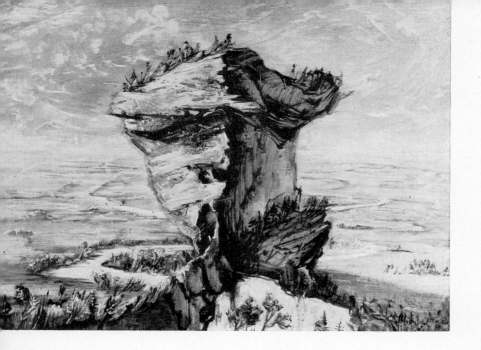

THE ROCK AND THE PLAINS. Above is the complete painting and below, a detail. The rocks were executed with a palette knife. This is clearly visible in the upper right-hand corner of the detail below.

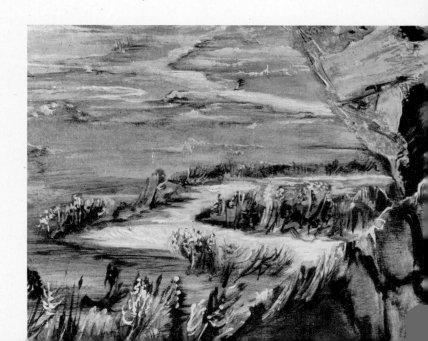

for cleaning brushes. Soap (or soap flakes) and water will do a much better job. Hardened paint can be dissolved with a paint remover.

PALETTE KNIVES

Three knives are reproduced on page 21. The first two are those we need, the third type, from my point of view, is useless. I would go so far as to say that the latter is popular only with those who do not understand how to use the palette knife properly. The two knives are of the essence in painting; and, the way I look at their function, every painting will show the imprints of a palette knife in some measure.

Since I attribute such great importance to this tool, I shall try to describe the action in detail—as far as this can be done in words, for the effects left by the knife on the canvas can be understood properly only by a visual demonstration.

To obtain a really suitable instrument is not always easy. Most of the commercial knives are too rigid. Very rarely can one obtain a knife with a tapered blade, as seen second from left on page 21. Thus, quite often, there is need for improving the characteristics of a new knife by grinding it down to a finer thinness, also by narrowing the blade to the size of that shown in the photograph. It must be understood that the flexibility of a blade is not a specific property of the metal, but that flexibility is determined by the thickness of a blade. All necessary corrections of the blade can be made easily by means of a grinding wheel.

Since the knife will be used to produce the finest as well as the broadest effects, a rather narrow, tapered blade is always preferable, for, when moving even the narrowest blade edgewise, its width will be immaterial. It must be well understood that it is the edge of the knife which is chiefly used, much less frequently its width, and practically never the tip. Effects produced by using merely the tip of the knife are invariably ugly textural definitions. In fact, such textural effects are the mark of beginners as yet unfamiliar with the working properties of the palette knife. The trowel-shaped type of palette knife, especially, seems to invite improper handling.

In priming—that is, when pressing paint into the interstices of the fabric—the knife should have a stiffer blade in order to perform this task effectively. A fairly inflexible blade, however, is useless for any manipulation other than scraping paint off the palette. A blade that is too flexible will also be useless, for it will defy the painter's efforts to distribute paint on the canvas efficiently.

This ends, for us, the list of implements used for painting. All these are essential, and no others, generally speaking, are needed.

CHAPTER III
PAINTING MEDIA

When you take oil colors straight from a tube, they are, as a rule, too stiff for effective manipulation on the canvas. Thus a diluent or medium becomes necessary for mixing with the paints, not only to achieve the right consistency, but also for the sake of preserving a painting after it is completed. Before a discussion of the nature and behavior of the painting media, however, a word or two should be said about the customary stand-bys in painting—linseed oil and turpentine, which are usually recommended as diluents and are used instead of a resinous medium by most beginners. Whether used straight or thinned with turpentine, linseed oil is not the ideal painting medium, although it is the only binder for grinding pigments that meets all our requirements.

The abundant use of linseed oil (as sometimes required in painting for glazing, scumbling, and generally for thin painting) is, however, inadvisable for the following reasons: tendency to yellow, insufficient viscosity, incapacity to add body to paints which improve in the presence of a heavy oil, moderate drying qualities. When mixed with turpentine (in moderate proportions, of course) certain working qualities of the oil improve to some extent, but not sufficiently to invite its use.

As for turpentine alone, although it has been the favorite diluent for paints with a great many painters, its use must be rejected because it is not only unsuitable in a paint technique such as discussed in this book, but when used profusely it also destroys the binding property of oil. Turpentine can produce a mat paint surface, it is true, and some painters favor this. But it must be understood that, from the viewpoint of permanence, flat surfaces are undesirable, for they will collect dust and make cleaning impossible without exposing the painting to serious damage. A glossy paint surface, on the other hand, indicates that the pigments are properly bound by the oil medium. The surface, therefore, is smoother and more resistant to atmospheric attacks.

The media used for painting have been the object of my special interest and research from the time I first tried my hand on working with oil colors, and I have come to discount most of the advice in regard to the commonly recommended painting media. In other words, I have, during more than thirty years as a practicing painter, quite naturally through endless experimentation arrived at my own

formulas for painting media. There are various kinds on the market and there are certain books that tell how to mix your own medium. However I must, naturally, recommend the media I personally find ideal and explain why. I feel sure that the reader will not want to take years of time experimenting with mixtures of his own and many of the books on the subject are confusing, to say the least.

To start with, I should like to state categorically that a medium containing relatively large proportions of the soft resins (such as damar and mastic) must be rejected because it endangers the permanence of a painting. Or, let us put it this way: paintings executed with a damar or mastic medium cannot be properly cleaned (no matter how old they become), for even a weak cleaning agent will soften the resinous paint and will often remove the delicate glazes altogether. Now, at first, the cleaning of a painting might not appear to be a problem, but it will surely arrive in years to come. In conditions such as prevail in cities burning oil or coal, paintings in time become obscured by dirt to such an extent as to alter materially the original color scheme and make a thorough cleaning imperative.

However, when copal resin (referred to as "hard" resin) becomes part of the painting medium, the danger of damage caused by removal of paint on the occasion of a picture being cleaned need not be expected. For this resin, with progressive age, solidifies with stand oil to a nonporous, tough, and highly resistant film. In formulating the copal media, I endeavored to produce a compound which would offer the best working qualities and be adaptable to the most diverse paint techniques.

It would be wrong to say that the formulas established by me are "my own" for these are neither new nor original. Or perhaps I should rather say that the ingredients which go into the formulas are entirely traditional, only their specific relationship has been reestablished for practical usage. The painting media I refer to are known as Copal Painting Medium (Light), Copal Painting Medium (Heavy), and Copal Concentrate. (For the convenience of the reader, these are manufactured by Permanent Pigments of Cincinnati, Ohio.) The three are of the same basic formula, but are of different consistencies for different uses which I will now discuss.

Copal Painting Medium (Light) can be used for thinning oil colors just as freely or with whatever restraint the painter may desire. Its adhesive properties are of such a high order that when applied even in water-color fashion—that is, in the thinnest consistency —it will not drip off the canvas. When overpainting with this medium at an early or late stage, one will not be harassed by the yellowing or cracking of paints. Although the medium is of rela-

tively high viscosity, it is not as high as that of the Copal Painting Medium (Heavy).

Copal Painting Medium (Heavy) is especially adapted for glazing,* that is, for diluting a color to make it quite transparent. This implies that with a greatly thinned paint a higher viscosity appears to be quite desirable. The heavier medium also produces a higher gloss, lending to the paints (if used profusely) the quality of enamel.

At this point we should turn to the question—what are the advantages of using a resinous painting medium? Briefly, the answer is this: (a) The presence of the resin enhances the depth, that is, the tone value of a color. (b) It promotes the blending and fusion of colors. (Oil paints, as they come from the tube, do not blend readily; and when used in profusion they will easily smear rather than flow one into another.) (c) The use of a resinous color also permits frequent overpaintings without impairing the permanence of the paint film. (d) Lastly, the drying capacity of a resinous paint is materially improved.

We have just referred to "resinous" paint, implying, as it were, that the use of the medium alone would bring about such a condition. This need not always be the case, for only paint which has been thoroughly mixed with this medium would be, in a true sense, resinous. But, in practice, one would dip one's brush at random into the oil cup and mix paints with the medium more or less perfunctorily. Sometimes one may prefer to use the colors entirely undiluted. Therefore, it is good practice to condition the paints at the time of placing them on the palette with Copal Concentrate.

Copal Concentrate will bring about the conditioning of paints as just described. This third medium is a solution of copal resin in stand oil. It is a heavy, salvelike, semiliquid substance of great viscosity. To incorporate it with paints, one should do the following: A quantity of the Concentrate should be scooped out of the bottle by means of a palette knife and placed on the edge of the palette, where it will not interfere with the paints. Then as much of the Concentrate as the tip of the palette knife will hold should be thoroughly mixed with each color placed on the palette. A quantity as large as a bean should be mixed with about one inch of the paint as it comes from the tube. All this should be done before starting to paint.

Colors conditioned in this way become much more unctuous, glossy, enamel-like. Flake white alone reacts to the Concentrate in a slightly different way, inasmuch as a small addition of this medium

* See page 71.

will make the paint extra stiff. When more of the Concentrate is added flake white will flow as easily as the other colors. However, even the stiffest paint can be made brushable by diluting it with the painting medium.

Although paints mixed with the Concentrate will be somewhat thinner than the original tube colors, nevertheless a further thinning with the Copal Painting Medium will, as a rule, be required. For alla prima painting—and this is our chief consideration in this book—such a resinous paint is of great value. When underpainting is planned, the use of the Concentrate (in the underpainting) is *inadvisable*, for it produces a smooth, nonporous surface to which the next layer of paint would adhere poorly. But here, too, good adhesion can be re-established by simply sandpapering the surface before painting on it.

Drier. Lastly, mention should be made of a liquid which promotes the drying of oil paints. Cobalt drier is such a liquid. It should be added to the colors as well as to the medium. As a rule, one or two drops of this powerful drier added to about one inch of paint (use the palette knife for thorough mixing), and one drop added to about one teaspoonful of the medium, will make the painting dry in a matter of hours. However, the paints must be thinly applied. A thick stratum of paint, although it will dry quickly on the surface, will remain wet within, unaffected by the presence of the drier, for a long time.

CHAPTER IV
OIL PAINTS

Doubtless your inclination will be to put in a supply of all the beautiful colors your dealer can offer, and the baffling question will be (baffling because there are so many kinds on the market)—what make of paints shall I choose? "Unadulterated" and "full strength" are among the descriptive adjectives most appealing to the painter in search of good colors, and most of the manufacturers claim these qualities for their wares. Unless experience teaches us better, most of us are inclined to think that the higher priced a product, the better it must be, which is not always the case.

The best counsel I can give as to the choice of any certain brand of paints is: on the negative side, do not use a brand merely because you have formed a sentimental attachment to it without really appraising it, and do not be wheedled by tales that a famous painter uses this or that line. But, when buying paints, *always* look at the manufacturer's label specifying the contents of the tube. If a color does not have such a label, reject it. (Thus you avoid the danger of some inferior material.) If you wish, further, to test the color yourself, using simple means that can be followed easily by any layman, I suggest that you read the chapter on testing colors in my volume *The Painter's Question and Answer Book.*

TINCTORIAL STRENGTH OF PAINTS

One cannot summarily assert that colors of "full strength" are always best or that they will guarantee the greatest brilliance for your paintings. Coloristic brilliance does not necessarily depend on the chromatic impact of your color, and full strength in a color is not always desirable. The fact is that some colors should have strong tinctorial qualities and others should not, or perhaps we may put it that way. In some instances you may need a powerful tint, in others the contrary would seem preferable. For example: the strong tint of mars yellow (an artificial ochre) may be excellent for use in landscape, but totally unsuitable for painting realistic representations of flesh tints. The same applies to venetian red (artificial iron oxide) which is by far too strong to be used freely for painting flesh. The much milder color known as light red (the natural red iron oxide) will be more appropriate in portrait and figure painting. (I should add here, however, that the nomenclature "venetian" and "light red" is often confused by the color manufacturer.)

To continue with the list of colors which will prove to be too strong for certain occasions, here we have the monastral (phthalo) blue and green, the darkest tints of iron oxide such as mars violet, also mars brown and mars black. All these colors are most useful when employed with the full understanding of their properties. The rest of the colors which are of great tinctorial strength are the pure cadmium sulphides, prussian blue, and the whites prepared from titanium pigment. Especially with the white color, a great tinctorial power becomes a dubious asset because of its readiness to reduce the value of all the other colors to pastel hues. In other words, the titanium white in mixtures with other strong colors such as yellow, blue, etc., will easily reduce the strength of these colors, whereas flake white, for example, will not have the same capacity for color reduction.

CHOICE OF COLORS

White. The only white color the painter should use is flake white (white lead). I do not wish to imply that the other white colors such as zinc or the titanium colors are unusable. But the white lead color offers too many advantages and none of the disadvantages of the other white paints, hence there is no reason for dispensing with it except, of course, if one is allergic to lead. As to the alleged poisonous qualities of white lead and its supposed incompatibility with some of the other colors, suffice it to say that one may as well forget about these charges. No one, I suppose, would eat the stuff, and in mixtures with the rest of our palette, or when mixed straight, it will not darken or blacken or otherwise behave in an undesirable manner.

I like to place the white on the palette between the cold and the warm colors. Let us review the former, which are grouped on the right side of the white, namely: ultramarine blue, prussian blue, viridian green, chrome oxide green opaque, and the other less important greens and blues.

Blues. Ultramarine blue and prussian blue are both transparent colors and are sufficient for all purposes where blue colors are needed—in landscape and figure painting. The other blue colors such as the popular cobalt blue and its greenish variation, cerulean blue, also manganese blue and monastral blue can easily be dispensed with. In flower painting, however, cerulean blue and monastral blue are pleasant to use as we shall see later. The inquisitive painter may want to explore the color possibilities of all the blues and greens on the market, but it must be said that by relying on the two recommended blues his progress will in no way be hampered. As compared to prussian blue, ultramarine is a much weaker color.

It has a violetish hue, whereas the former is greenish, a quality which makes it most valuable in landscape painting.

Prussian blue does not require an addition of Copal Concentrate (Chapter III) because it is mixed only in small quantities with the other colors. Ultramarine should receive a small addition of the copal compound.

Greens. Viridian green and chrome oxide green opaque. The first must be considered as indispensable and the second as most useful. Viridian green is a highly transparent color of moderate tinting strength, whereas the chrome oxide green is entirely opaque, dull, and possessed of great tinctorial power. Viridian is a somewhat brittle and lusterless paint as it comes from the tube, hence it improves greatly when mixed with Copal Concentrate. The chrome oxide color, too, becomes more brilliant in the presence of the resin compound.

The other green color of limited usability is monastral green. It is related to viridian as regards color but its hue is brighter, more transparent, and somewhat suggestive of a dye. All the other greens, whatever their name, should be thrown out of the palette box, if they have found their way into it, and without any regret whatever.

This ends for us the list of cold colors on the right side of our palette.

Yellows. On the left side of the white, I like to start with the warm colors—barium and naples yellow and continue with the yellow ochre, strontium yellow, cadmium yellow, etc.

The omission of raw sienna from the list of yellow colors may seem conspicuous, but personally I have found that the mars yellows have greater usability than the raw sienna and really make it superfluous. However, there is, of course, no objection to using the raw sienna, as well as the golden ochre, which is a transparent variation of the yellow ochre.

The above list looks like a large catalog of yellows. Though some may be used only occasionally I would not wish any of them to be missing from the collection.

When I refer to barium yellow, I have in mind specifically the Permanent Pigments' product, which differs greatly from the barium yellows of other manufacturers. It is a lifeless, pale, transparent yellow, yet for achieving certain atmospheric effects, it is quite valuable. It must be well intermixed with Copal Concentrate, since it is soft and entirely lacking in viscosity.

Naples yellow is an opaque pale yellow (pale as compared to cadmium yellow). In most cases what is labeled "naples yellow" is really an imitation—generally a mixture of white, cadmium yellow,

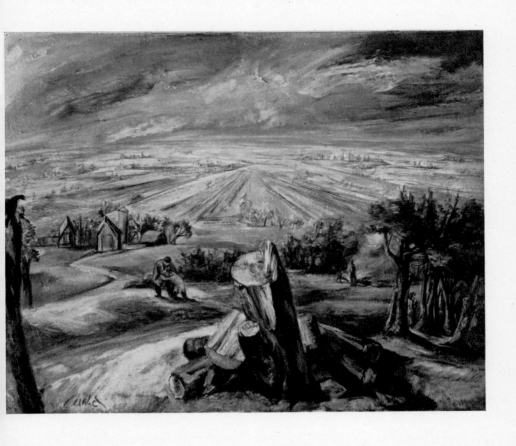

THE RETURN OF THE PRODIGAL SON. An alla prima painting over a yellow toned ground. A yellow ground is suitable for landscapes and flowers.

THE GRAY BIRD. A painting executed on a pink toned ground

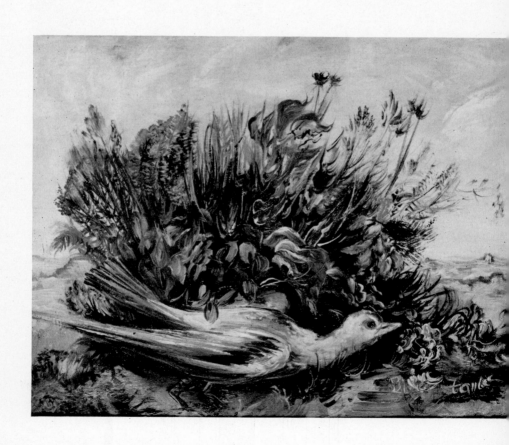

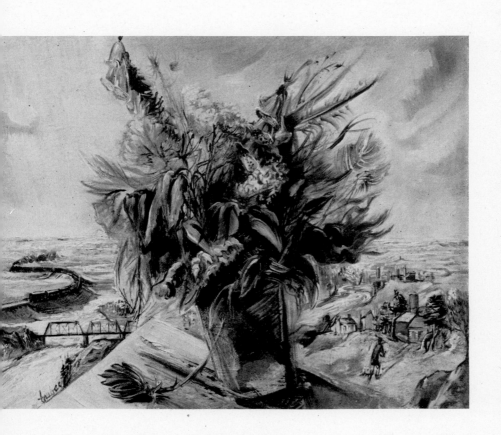

TILL LIFE WITH HOME-COMING AND DEPARTURE. This alla prima
ainting also carried a pink ground, but with the addition of a partial multi-
olored imprimatura.

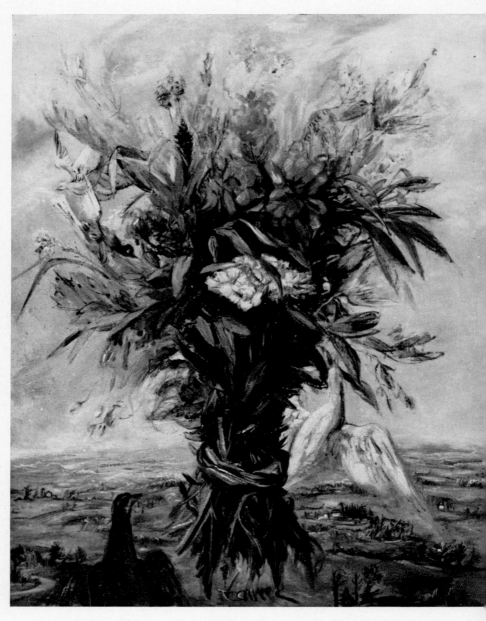

FLOWER BOUQUET. Painting on a multicolored imprimatura.

and perhaps some ochre—and although such a color may appear to match perfectly the true naples, in mixtures with other colors it will show its deficiency. Therefore, when buying naples yellow one should look for a label designating the paint as "lead antimoniate."

Strontium yellow is not a popular color, but I have found it useful in landscape and still-life painting. One might say that strontium yellow is to cadmium yellow what barium is to naples yellow. This implies that its tinctorial properties are weak and its hiding power slight. Both these colors, to work properly, will require a substantial addition of Copal Concentrate.

Light ochre is the old, absolutely indispensable stand-by. This somewhat coarse and rather opaque color will find its way into practically every painting. Its dullness will be greatly improved when mixed with Copal Concentrate.

In cadmium yellows, one should differentiate between the cadmium-barium colors and the pure cadmium sulphides. The former are not as powerful as the latter and are much lower in price. Although cadmium-barium is excellent for all-round use, it is quite important to have a yellow color of maximum tinctorial strength. Hence, one should see to it that the label specifies the color as a pure cadmium sulphide. Cadmium yellows come in a light, medium, and dark variety. Which one is best to have depends on the individual's taste. Cadmium orange can be obtained from mixtures of cadmium yellow and cadmium red, but it is quite convenient to have the color ready in a tube.

Reds. Cadmium red should be the pure cadmium selenide and not the cadmium-barium color, for the glorious, strong hue of the red color is all that counts. It is easy to reduce the strength of any color, if one so desires, but you can hardly potentiate a primary color's hue beyond its inherent strength. Under certain circumstances I would give up the cadmium red altogether in favor of the old-fashioned vermilion. But here again, what is generally labeled vermilion on the tube is not the genuine color. If a domestic tube carries the label "vermilion" it should also specify that it is a mercuric sulphide color.

When referring to cadmium or vermilion, I have in mind the brightest shade only, not the medium or dark red colors, which I consider rather useless. But, if an occasion arises for using a purple shade of this color, an addition of alizarin crimson to the light cadmium (or vermilion) will produce it.

The other red colors of interest to us are: venetian red and light red, mars violet, indian red, and burnt sienna. The latter is really a brown color, but when used in transparent fashion it appears red.

A purple, deep red color, is also the alizarin crimson, one of the most transparent colors on our palette.

As mentioned earlier in this chapter, venetian red is a powerful iron oxide, and light red (the natural earth color), because it contains a large amount of clay, is much milder. Thus, whereas a certain quantity of venetian red, with a certain quantity of white, will produce a dark pink, light red mixed with a like amount of white will appear as a bright pink. Mars violet is a darker purplish variety of venetian red and although one would not habitually reach for it while working, at times it can become quite desirable.

As for burnt sienna, although it is of little interest when used alone, for intermixtures with other colors (and as a glaze) it is one of the most desirable colors on our palette. Its drying capacity is, next to umber, greater than that of any of the other colors. All these earth colors gain color value in the presence of Copal Concentrate.

Umber is the only dark brown color we will need and it is one of the most versatile. In itself, umber is dull and of no particular beauty, but it will enter into mixtures with many other colors and, since it is the best dryer on the palette, it will make all the other colors dry out quickly, even if added to these colors in minute quantities. Umber is obtainable in a raw and a burnt variety. The latter is made by calcining (roasting) the raw color and in this process it acquires a reddish hue. I prefer to use the raw color for preparation of priming (see Chapter 1) and burnt umber for flesh tints and most other occasions.

The remaining colors on the left side of our palette are ivory black and alizarin crimson. Both require a relatively large addition of Copal Concentrate to become pleasant in use. The Concentrate will not only condition most effectively the body of these fine-textured paints, but it will also greatly improve their poor-drying capacity.

To sum up, our list of colors will include sixteen in all: flake white, ultramarine blue, prussian blue, viridian green, chrome oxide green opaque, cadmium yellow, strontium yellow, barium yellow, ochre, cadmium red, venetian red, mars violet, burnt sienna, umber, ivory black, alizarin crimson.

The above palette remains still workable when deprived of the following paints: chrome oxide green opaque, mars violet, strontium yellow, barium yellow, thus leaving twelve paints in all, the absolute minimum for unhampered work.

For the color gluttons however—and your author is one of them—I recommend the following ten additional paints: monastral blue and green, manganese blue, cerulean blue, mars yellow (transparent and opaque), zinc yellow, cadmium orange, mars brown, mars black.

RESUME OF THE COLOR VALUES WHICH COMPRISE OUR PALETTE

Center of palette: Flake white.

Cold colors: Viridian (bottle green, rather dull). Chrome oxide green opaque (a tough, inanimate, dull green). Ultramarine blue (sweetish sky blue with a tinge of violet). Prussian blue (greenish deep blue). Cerulean (greenish, light, rather opaque blue). Monastral blue (neutral, powerful blue). Monastral green (a clear, strong, transparent bottle green).

Warm colors: Barium yellow (palest, faintest, very transparent yellow). Strontium yellow (greenish yellow and more transparent than the zinc yellow). Zinc yellow (less brilliant by far than the cadmium yellow). Cadmium yellow (the brash, clear sun color). Ochre (the color of a yellow rock; some sorts are dull, others show more life). Mars yellow (resembles ochre but has much greater tinting strength). Cadmium red light, or vermilion light, (a brilliantly glowing orange-red). Venetian (light) red (brick red). Indian red, mars violet (dark, purplish, brick red). Burnt sienna (as a glaze—a fiery, low-keyed red; used in impasto—dull reddish brown). Umber (dull, dark brown). Mars brown (dark, reddish brown). Ivory black (neutral deep black). Mars black (dull, flat black). Alizarin crimson (as a glaze—a fiery, deep red; in impasto—a dull, purplish red).

CHAPTER V
INTERMIXTURE OF COLORS

It is quite understandable that a painter who is not familiar with his colors dips his brush at random, hither and yon, and hits upon a particular combination by sheer luck, perseverance, or both, but it could serve his purpose better to know what he may expect from intermixture of certain colors. Not all the colors can be combined one with another and, without knowledge of compatabilities and idiosyncrasies, color mixture will sometimes yield highly undesirable effects. Since this book aims at simplification of color problems, I believe it will serve the purpose better if I refer to certain specific occasions when certain specific colors will most likely find their best use.

FLESH TINTS (Portraits)

Light (yellow) ochre, light red, umber, ultramarine blue, and flake white are the colors you should have at hand. Flesh as seen in full light calls for ochre and white alone, and perhaps some light red for pink nuances. The shadows can be approximated with umber, ultramarine, ochre, light red, and as much white as needed to make the shadows light.

This may seem like a lot of colors to be mixed together, but they are all complementary to one another in a most harmonious way. To explain the material affinity of these colors, consider: ochre lightens the hue of light red, makes it more lively and animated; light red adds life to umber, and ultramarine grays umber to more neutral hues; ultramarine and ochre will green the color of the shadows, but if you do not like the greenish nuance, light red will quickly neutralize it. White, as I have said, is important to keep the other colors in check, but too much white will reduce all the other colors to pastel tones, and will render them opaque.

Now, one need not necessarily use all the colors mentioned for painting shadows; one or another (with the exception of white) can be omitted. Thus umber, ultramarine, and ochre will produce variations of cool tones and red, umber, and ochre will account for a warm tonality of the flesh color. One can also paint shadows very well with umber and light red alone. The dark complexion of a negro, for example, can be painted with ultramarine and umber, in light as well as in the shadow parts. Both the transitional colors—

that is, the half shadows—will be obtained by simply blending the lights with the shadows.

There will remain, in portrait painting, a few extra problems— the colors of hair, eyes, and lips, which may require some additional colors. Blond hair may call for naples yellow, red for burnt sienna (used as a glaze). Black will be produced by mixing ultramarine and umber. Lips may be painted with light red and alizarin crimson. But beware of that lipstick effect—alizarin crimson, when used abundantly, will surely produce it! As a rule, umber and light red are all one would wish to use for painting lips.

In portrait painting (with desired paraphernalia or trappings) the additional colors, cadmium yellow, cadmium red, viridian green, and ivory black, will take care of any background emergency such as may arise when painting an armored knight plus a distant battle scene, or a landscape, a calm sky, or perhaps some fiery volcanos, depending on the particular background theme.

COLORS FOR LANDSCAPE PAINTING AND HOW TO USE THEM

Skies. In painting skies, of all the blue colors we possess prussian blue seems to be the most versatile. Because of its aggressive hue, however, it cannot very well be used without a modifying color and this invariably will be umber. Raw umber will gray down the blue, producing a neutral color, while burnt umber will produce a somewhat warmer tonality, depending on the quantitative relation of these two colors. For painting either skies or clouds, an endless variation of blues, blue-greens, and grays can be produced with these colors, and when we add naples yellow to this ensemble, practically all the situations normally found in placid or stormy skies, will be well taken care of. Of course, skies such as one imagines must have prevailed when Sodom and Gomorrah went under will have to display some sulphuric fireworks, into which all the bilious colors you like might fit nicely!

But, to return to our bucolic skies, here you have, besides the serene prussian blue, the saccharinated tranquility induced by ultramarine blue. Surely one would not wish to use ultramarine blue straight as it comes from the tube! If you do, you will inexorably out-calendar anything seen on the chromos for the month of May. So here, too, remember that *umber* and *viridian green* will act as good samaritans, rescuing the ultramarine from its ultra affability. If you tone down ultramarine with some burnt sienna, an arcadian situation will arise, especially when some feathery, wispy clouds are woven into the blue dome.

41

And, speaking of clouds, ultramarine or prussian blue can be conditioned with umber, burnt sienna, and ochre to produce all kinds of agreeable effects. Should we attempt to potentiate the dramatic spectacle of the celestial cupola, the following colors can be mobilized to paint clouds: venetian red, viridian green, black, strontium yellow. But we also have situations such as can be seen at sunrise or sunset, where the demand on our palette may exceed common propriety, so to speak. Then cobalt blue, cadmium yellow, and cadmium red and (Lord forbid!) alizarin crimson and cobalt violet may enter the field. Should such a temptation ever come over you, remember, reader, only the ones whom fate loves dearly could use these colors for skies and get away with it. Wait till we come to flower painting (page 50), then some of these colors may be found to be more appropriate.

Another blue color which can be used advantageously is cerulean blue. Proverbially the beautiful color for the space above, it is, despite its somewhat greenish tonality, a little sweet. This color can be produced by mixing viridian green, ultramarine, and white, but the original cerulean color—which, incidentally, is not easy to obtain—will behave differently in mixtures with other colors. Of course, when considerably cut with white, all the blue colors can be used straight, for the white will reduce and neutralize even the strongest colors such as the monastral blue and green, both of which can also be used for painting skies.

I have tried to arrive with the reader at a realistic representation of skies, for this book should aid the painter in following nature. Too often we see examples on the one hand of the picture-postcard school of unreality and on the other of mere expressions of bad humor dangerously approaching the nonsensical. It must be frankly admitted, however, that in the realm of self-expression and subjectivity no valid recipes can be given—here the mysterious processes of creativity find their own inescapable manifestation. But, beware, painter, of the false prophets who will offer their obstetric devices to unearth the source of your so-called creativity, without references to nature, for surely you will end up producing some patent monstrosities.

The greens in a landscape. Now let us tackle the realm of the chlorophyll—that is, all kinds and manner of vegetation. And let us consider how they will coordinate themselves as regards color, in the general problem of a landscape. And so, at the risk of a well-worn truism, let us reassert that the scale of green colors can range from the nuance which would most admirably express certain delicate shades of melancholia to the bilious color which we may call justly

"poison green," such as is found in some luscious cow pastures. This cow-pasture green seems to have great fascination for the beginner, whose brush will unfailingly find its way into cadmium yellow and then into ultramarine or prussian blue. Needless to say, only occasionally and on limited areas such greens may not offend the sensibilities of a trained eye. But here is the way out—an addition of black or white (or both) can condition pleasantly the most bilious of greens.

Tough, sinewy greens, low in key and never offending, can be obtained from chrome oxide green opaque and black, or the former can be neutralized with one of the iron oxide reds (venetian, indian red, or mars violet), or it can be brightened with cadmium yellow.

Again, strong, local greens, no less powerful than the cadmium-prussian blue alliance, but by far more aggressive to the eye, will result from an umber-cadmium yellow combination. To continue with the local greens, such as are observed in nearby trees or bushes seen in brilliant light, black and cadmium yellow or black and zinc yellow will be the suitable colors, the latter providing milder hues than the former.

As mentioned, green as it appears fully lighted may well be obtained without the blue color; but when seen in shadow, blue may become the more logical choice. Here again beware of pitfalls. Nothing can become more tedious than the conventional impressionistic yellow-blue color scheme, or, what is surely the worst abomination— the yellow-violet juxtaposition. Therefore, we should keep in mind that the ivory black color (instead of the blue) in mixtures with cadmium can make all the difference in our green color scheme. It should also be remembered that umber plus ultramarine (or prussian blue) yields a black that can be used in combination with cadmium yellow. This implies that umber will neutralize the blue, thus mellowing it for the alliance with the yellow. Darkest greens can also be obtained from mixtures of prussian blue and burnt sienna. The transparent qualities of burnt sienna together with the transparent prussian blue make for a most sympathetic color combination. Although white will do well to reduce the hue of powerful greens the delicate cerulean blue can also be used for greens of a low hue.

At last, as we progress to the picture's more distant planes, the aggressive cadmiums can be altogether omitted. Instead, strontium or naples yellow will be our choice. The yellows of a lower key will always have the tendency to remain in the background and will not jump out; as it were, and push their way into the foreground.

The greens can be removed still farther and farther, first by mix-

43

ing viridian green (in combination with naples yellow and white) and then making them fade by adding white. The more and the paler the blue and the green color (especially the greens produced from viridian), the more distant their location will appear on the picture's plane. This principle of atmospheric perspective is very simple. Drain the color of its potency, or render it blue, and you will produce the effect of distance. Since such an arrangement relies on observation of realistic phenomena, today it is considered by aestheticians of the advanced faction as antiquated. Were you, however, to follow perspective principles of, let us say, the Byzantine school (which antedates the empirical conception by a thousand years) at once you would become, in the eyes of our modernistic experts, a "progressive."

To continue with distance in landscape: the conditions of getting lighter and paler suggest an increased use of the white color, hence an increased opacity for, as we remember, flake white possesses considerable opacity. Now we have learned before that it is the transparent colors which suggest atmosphere and buoyancy, and here, it seems, we contradict our statement. Moreover, we do not use glazes in the background. The answer to this apparent inconsistency is simple: in oil painting the solid white is the only color to cut radically the hues of any of the other colors or combination of colors; in spite of its material appearance, white will suggest a lack of color, hence the sensation of infinity.

Besides the reduction in color value, there is another way to produce the sensation of distance—the vagueness of contours. Whereas the contours of motifs as they appear in the foreground is definite, as a rule, in the background, these contours will become soft and blurred and eventually the distant motif may lose its defining contours altogether.

COLORS OF MISCELLANEOUS OBJECTS IN A LANDSCAPE

Rocks. Gray, a color we always need for this subject, can be best produced from mixtures of prussian blue, umber, and white. Add to this list ochre and burnt sienna and rocks of all descriptions can be painted satisfactorily. The color strategy will here be as follows: cardinal gray color can be influenced toward green by adding ochre to it; or gray can turn toward pink by adding burnt sienna. So here we have the varied possibilities of painting rocks in the following colors: (a) blue (prussian blue and white); (b) gray (prussian blue, umber, white); (c) green (prussian blue, ochre, white); (d) brown (ochre, umber, white, or umber, burnt sienna and white); (e) pink (burnt sienna and white); (f) black (umber and prussian blue). In

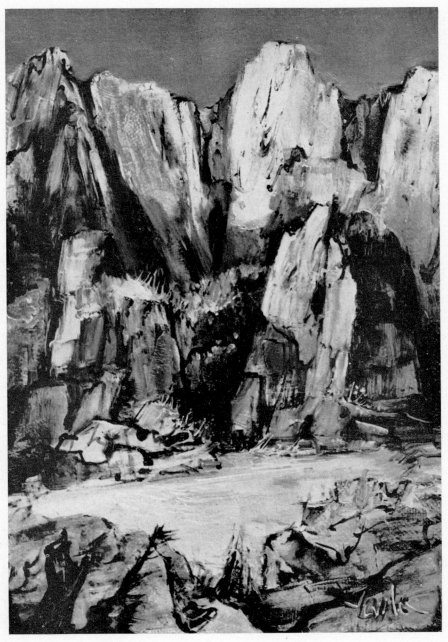

EMERALD LAKE. Done in one sitting, this painting on a yellow ground shows rock formations painted with the palette knife.

Sketches demonstrating (right) a grayish-brown toned canvas with burnt sienna imprimatura, (left) a grayish-brown toned ground with an additional ground of pink and a viridian green imprimatura. (See page 54 for more detailed discussion.)

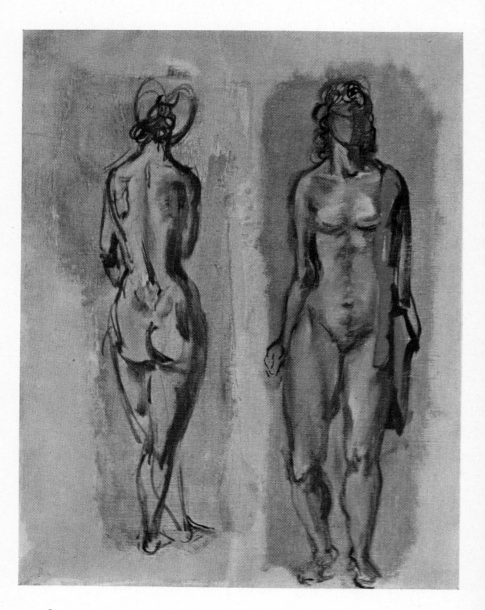

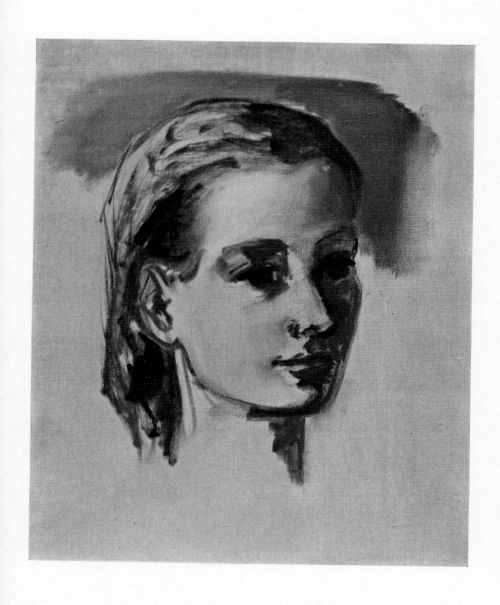

An unfinished portrait study which, like the sketches opposite, demonstrates the alla prima technique in process. The toned ground is the same grayish-brown made with ochre and white. See page 54 for further notes.

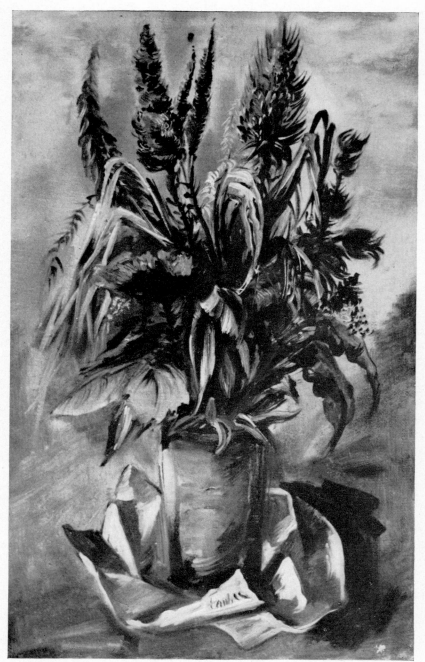

FIELD FLOWERS. An alla prima painting on a yellowish toned ground.

other words, with these four standard colors (and white), endless color effects for painting rocks can be produced. However, there may, at times, be need for a high-keyed color; a yellow stronger than ochre can provide, more red than burnt sienna. In the first instance ochre can be strengthened with cadmium yellow and burnt sienna with cadmium red. I have omitted venetian red from this list because when mixed with white its pink color is rather abstract, which means that it does not evoke in our imagination any specific quality or objects, whereas the murky pink of burnt sienna is highly suggestive of concrete matter.

Another color to be mentioned in connection with painting rocks is ivory black. Where a bluish color range is not required, black will do well in replacing umber and prussian blue. It is most sympathetic toward burnt sienna and ochre and together with these colors it will often suffice for producing a rich range of color nuances.

When selecting a color or a group of colors, it is important to keep in mind the cardinal consideration: Do we plan for a cold or a warm tonality, or should the colors be neutral? This consideration will decide for us whether we shall rely on the predominance of burnt sienna (a warm color), for example, or on black which with white will produce a cold color. In picture-making, the strategy of playing warm masses against areas painted in cool colors is of utmost importance.

At this time, I should like to point to the fact that practically all color combinations listed on the preceding pages, rely, in the main, on two colors (and the white). This suggests a certain deliberate procedure. First, no more than two colors should be considered, for then accurate predictions as to the outcome of the alliance can be made. Once the principal tonality of a given color scheme is obtained—that is, more or less determined—we can proceed with influencing the scheme in either direction, warm or cold, also dark or light. The reason for such a procedure is simple: two colors mixed together will, more often than not, retain their identity. When a third color is brought into play the mixture will become infinitely more complex. Four or more colors mixed together will, no matter how brilliant they may appear individually, yield a dirty, nondescript smear. Of course there is one way of retaining the colors' identities and purity: refrain from a thorough compounding of the paints. The less the colors are mixed the more brilliant they will appear.

This exposition implies that the choice and handling of colors is not a matter of emotional impulse but rather the result of deliberate calculation. Of course, with an expert, the deliberate calculation becomes part of a subconscious automatism.

49

Water. When it mirrors the color of the sky, the color scheme will not differ from that used in painting skies. But, in addition to the blues and grays, viridian green is, in my opinon, quite indispensable. Water can, under certain conditions, appear entirely opaque and dull. Ivory black, ochre, viridian, and white, will here be the colors to deal with. Sunlight can do all manner of tricks to water in motion, and the serious observer will find his way of expressing it. We will not, however, go into the chromo effects which may be seen on picture postcards of agitated seascapes, for this book is not designed to encourage the production of such monstrosities.

COLORS IN FLOWER PAINTING

In the matter of portrait or landscape painting, economy with regard to the number of colors used seems reasonable. To manifest such reasonableness when painting a flower motif, however, is absurd. The very limitation of the subject matter demands concentration on the color element more than on anything else. Although one can paint a figure with a very few subdued colors, relying on closely related values, and achieve by this means extraordinary effects, and although a similar principle, with certain reservations, can be applied to painting landscapes, the flower motif stands or falls on the strength and richness of the colors which the painter is able to master. Surely I am aware of the fact that a still-life composition may rely on the intricacies of a cunning design, but emphasis on decorative delineaments alone, puts a painting in a different class altogether—one which, being removed from reality, does not concern us in our present discussion. Such paintings may be executed better in relation to a given color scheme or decorative theme of which they form a subjective part, such as in a hotel bedroom, powder room, or boudoir.

In flower and still-life paintings, the few specific colors to which I referred previously in a rather disrespectful manner will become at once not only welcome, but they may dominate all the other colors. On the other hand, some colors most useful in painting figure compositions can be omitted altogether simply because they do not suggest, by way of mental association, an animation such as we are accustomed to see in flowers.

Therefore, in painting flowers, our basic list of colors will be as follows: flake white, viridian green, monastral green, prussian blue, cerulean blue, monastral blue, chrome oxide green opaque, naples yellow, zinc yellow, strontium yellow, cadmium yellow, cadmium orange, cadmium red or vermilion, ochre, venetian red, burnt sienna, black, alizarin crimson.

I referred previously and with disdain to the candy-color effects produced in landscapes by using white with alizarin crimson and cadmium red but in painting flowers the situation changes radically. What might be a nauseating color in mass in landscape painting, or could produce a vulgar effect in a portrait, becomes eminently acceptable on the petal of a flower.

Let us see what varied combinations of colors for flower painting can now be evoked, for all barriers have been lowered to admit an incandescent riot on our canvas: viridian green—prussian blue (or monastral green). Viridian green (or monastral green)—naples yellow, zinc yellow, strontium yellow, cadmium yellow, cadmium orange, ochre, vermilion, venetian red, burnt sienna, alizarin crimson. (Prussian and monastral blue can be used in similar combinations.)

Naples yellow—cadmium orange, vermilion, venetian red, burnt sienna, black, alizarin crimson.

Cadmium yellow—also cadmium orange, zinc, and strontium yellow—vermilion, venetian red, burnt sienna, black, alizarin crimson.

White, as usual, will enter into the combination of most of these colors. However, the most important thing is to avoid thorough compounding of colors, for the most glowing colors can thus be reduced to lifeless indifferent stains.

Let us now examine closely a few of the more unusual color combinations: the admixture of white to alizarin crimson will at once bring out a purple which you never could have supposed dwelt within it. When mixed swiftly, with only a few strokes of the palette knife, the color can be most attractive, but try to compound it thoroughly and you will arrive at a lilac color so dearly loved by the enthusiastic beginner but entirely unacceptable in any serious painting.

Then we have cadmium red with white. This will suggest raspberry, at its worst, when used for practically any occasion except flower painting. For on a flower, the sweet pink can become most attractive. The same applies to a pink obtained from mixtures of cadmium red and naples yellow.

Cadmium yellow and alizarin crimson, swiftly brushed together or swept with a palette knife, will have a flamelike effect. And zinc yellow, because of its greenish tonality, will, on top of vermilion, make your head swim with delight. Wonderful color contrasts can be produced with vermilion and monastral green or blue.

As for greens, one should consider those obtained from black (and yellow), blue (and yellow), viridian (and yellow), umber (and yellow), also from prussian blue and burnt sienna. Every one of these

green combinations will be different and will have its own intrinsic value.

Regarding the problems of the background—it is logical to keep it in neutral colors, or at least in pale colors. Gray can be produced for this purpose from viridian green, venetian red, and white. Grayish greens will come from viridian, burnt sienna, and white. Also black, naples yellow (or ochre), and always white can be used to set off the strong color scheme of the flowers advantageously.

RESUME OF THE PALETTE RECOMMENDED FOR DIFFERENT SUBJECTS

Portraits. Flake white, light (yellow) ochre, light red, umber, and ultramarine blue for flesh tones, shadows, eyes. Naples yellow, umber, ochre, burnt sienna, ivory black for hair colors. Light red and alizarin crimson for lips. For backgrounds in addition to the already mentioned colors—cadmium yellow and viridian green.

Landscapes. Flake white, ultramarine blue, prussian blue, viridian green, naples yellow, yellow ochre, cadmium yellow, cadmium red, venetian red, umber (raw or burnt), burnt sienna, black. Supplementary colors: cerulean blue (or cobalt blue), strontium yellow, zinc yellow.

Flower paintings. Flake white, viridian green, monastral green, prussian blue, cerulean blue, monastral blue, chrome oxide green opaque, naples yellow, yellow ochre, zinc yellow, strontium yellow, cadmium yellow, cadmium orange, vermilion, venetian red, burnt sienna, ivory black, alizarin crimson.

CHAPTER VI
THE PRACTICE OF PAINTING

The gist of the classical or traditional techniques, as distinct from all other oil techniques (which are haphazard and do not follow any logical course), has to do with the method the painter adopts in laying the foundation for his work, as well as with knowledge of the action and reaction of paints and media. Good paint quality, dependable colors, and permanence (with improvement rather than deterioration as time goes on), all hinge upon sound painting procedure.

In traditional technique there are several methods which have come down to us, each having its own special function and appropriateness. These are: alla prima painting, underpainting, imprimatura painting.

ALLA PRIMA PAINTING (A Painting Finished at One Sitting)

As the term implies, in following this method the painter aims from the start at the final color effects without a preliminary underpainting. In other words, he completes a painting at one sitting.

In opposition to the alla prima method, let us for a moment consider the function of an underpainting (or several underpaintings) which is as follows: (1) to create textural effects such as an alla prima painting could hardly produce; (2) to work toward the completion in a tentative fashion, using in the underpainting predominantly neutral colors; (3) to give glazes, applied later, maximum play, by providing for them a multicolored foundation.

Thus alla prima painting and painting on an underpainting are two different approaches, and one would be inclined to believe from the foregoing that when employing underpainting a potentially higher artistry can be achieved. Theoretically such a consideration would seem to be justified, but in practice this is not necessarily the case. The best work of Pieter Brueghel, Frans Hals, Rubens,* and Degas,* to mention only a few, were all done in alla prima technique. Whether one resorts to frequent overpainting, or favors one single painting operation, is a matter of individual temperament and inclination. However, with the requirements of the part-time painter in view, the alla prima technique is stressed here as the quickest way

* See color plates on pages 66 and 67.

to paint well. Nevertheless, the method of underpainting is discussed later in this chapter.

In the color plates on pages 46 and 47, two methods of painting are demonstrated. Both of these examples must be looked upon as alla prima, although, in the strictest sense, we could consider that there does exist an underpainting of sorts. As can be seen in both examples, the studies were not painted on a white canvas but on a light gray-brownish ground (umber and white). This toned ground was applied on top of the white canvas, well in advance of painting (see Chapter I, The Preparation for Priming or Toned Ground). In the example of the figure studies we see, moreover, a semitransparent green color (veridian) in the figure at the left and a red color (burnt sienna) in the figure at the right of page 46, which cover the toned ground. This thin color, or imprimatura, as we call it, was also applied before starting to paint. Later we shall hear more about this subject (see page 61).

PORTRAIT PAINTING

Those who practice portraiture or figure painting should, as soon as they acquire a canvas, proceed at once to change the original white ground to a color which would expedite more efficiently the painting of a portrait or a figure. It is decidedly advantageous to have on hand a stock of toned-ground canvases (or panels) for such a ground cannot be applied immediately before painting. In one single operation, the painter cannot very well cover the canvas with a colored ground and then start to paint into this wet color. Since the nature and preparation of the toned ground was described in Chapter I, we shall proceed now with description of painting *on* such a ground.

The toned ground should, as we know, be neither too light in color nor too dark. In fact, it should suggest what might be termed a middle tone, such as is found in the transitions from dark to light on a head which has a clear definition of light and shade. This middle tone will greatly simplify the progress of our work, as we shall presently see. In fact, the color sketch on page 47 was made in about ten minutes and the complete work, with all details, could have been done in less than one hour. Of course, if the painter has to struggle to achieve a likeness, such a difficulty can materially prolong the progress of the work.

The capacity for achieving a likeness, although it depends, as a rule, on the co-ordination between the hand and the eye, is a matter of a specific gift; we can call it a "knack." Some beginners have this capacity to render likeness without apparent effort, then again

experienced hands may encounter difficulties in this respect. Perhaps an element of imagination enters the field here, a faculty for objective seeing, and this faculty will in the end decide how successful a portrait painter will be. The search for the sitter's likeness might at times seriously handicap the painter. For it is obvious that repeated restatements will, more likely than not, weaken the impact of the brush, and the task of faithfully reproducing the observable will call for the creation of more deliberate, careful, well-behaved brushwork. In the event that working over a painting has produced too heavy an impasto in certain places for a satisfactory finish, it would be better to scrape the canvas down for a new start. Refer to page 71 for notes on correcting finished paintings.

Painting a portrait alla prima on a toned ground will develop as follows: a charcoal sketch of the sitter should be made either directly on the canvas or on thin paper first and then transferred to the canvas. (A charcoal-covered paper is used here in the manner of a carbon paper.) The transferred charcoal drawing should be fixed by means of a charcoal fixative, or it can be gone over with a turpentine-diluted color, such as light red, umber or burnt sienna. At any rate, this sketch should, in the main, stress the contours and the principal proportions. Definition of light and shade effects, as well as details, are unnecessary at this stage. The color sketch on page 47 was made directly on the canvas (without the preliminary drawing), using a pointed sable brush dipped in a thin umber color.

As I have mentioned before, it is imperative to moisten the canvas with the painting medium before starting to paint. The medium should be applied with a stiff brush, which means it should be well rubbed into the toned ground and should not drip all over it. The inexperienced always have a tendency to use too much of the medium, and they generally use it in a haphazard manner, leaving parts of the canvas dry. To avoid this, when applying the medium, look at the canvas from a slant toward the light so as to observe the gloss spreading over the surface evenly. Excess of the medium should be scraped off with a pliable palette knife. An even distribution can also be effected by rubbing the medium into the canvas with the heel of the hand. On a surface prepared in this manner, the brush will slide with greater fluency and the colors will fuse and blend more readily.

Back to our illustration on page 47. The shadows on the face were painted with umber, some light red, and white. Ultramarine blue and umber were used to sketch in the hair and the eyes (no white was used, hence they appear black). The highlights on the hair were derived from the toned canvas. That means, the black

paint, which first covered the entire surface, was wiped off in places with a rag to reveal the toned ground, the color of which provides the highlights. On the upper part of the face (the part in light) ochre and white were painted in and then the color of the shadow was merged with the light by brushing them together lightly. Here the flat sable brush will effectively produce gentle blending of colors. The blending of light and shade will offer no difficulties even to a beginner, because the middle tone of the ground facilitates this work. In fact, such blending can be done easily with a few movements of one's fingers.

The lower part of the face carries only the definition of shadows. It was purposely left unfinished in order to demonstrate more clearly the progress of the work. As I have said, this sketch took about ten minutes' time. In finishing it, one would concentrate on a more detailed modeling and on refinement of colors.

When painting on toned ground, there is no need to lay in a preliminary background at the start, for the color of the toned canvas does this service. In our sketch, ultramarine, umber, and white were used (in the right upper part of the picture) to indicate, perhaps, the definite color of the background, and on the upper left side some ochre was added to the mixture. This was all done to demonstrate that the entire work could have been done by using the most simple basic color scheme: umber, ochre, light red, ultramarine, and white.

In the other color sketches, page 46, the figures were painted on a toned ground identical with the one used in painting the head on page 47. (That is, on an umber-white color.) Over the umber-white ground at the left, a second ground of pink color was added (venetian red and white) over which, upon drying, a viridian green imprimatura was superimposed. The sketch itself was next painted after the imprimatura was dry. The pink color being applied on top of the umber-white ground appears a little dark. It would have been more luminous if the pink color had been spread on a white canvas, for the light colors are rarely entirely opaque unless used with impasto, that is, applied thickly. The pink ground was, like the first toned ground, spread with a palette knife which, as we know, can produce a very thin layer of paint. A brush could have produced a much thicker paint film, also it would have left some harsh marks. Of course such marks can be flattened by means of the soft-hair blender and a very pleasant paint surface can thus be prepared. To the right of page 46, the same process was carried out with the umber-white toned ground over which a burnt sienna imprimatura was applied and the figure painted on top of this.

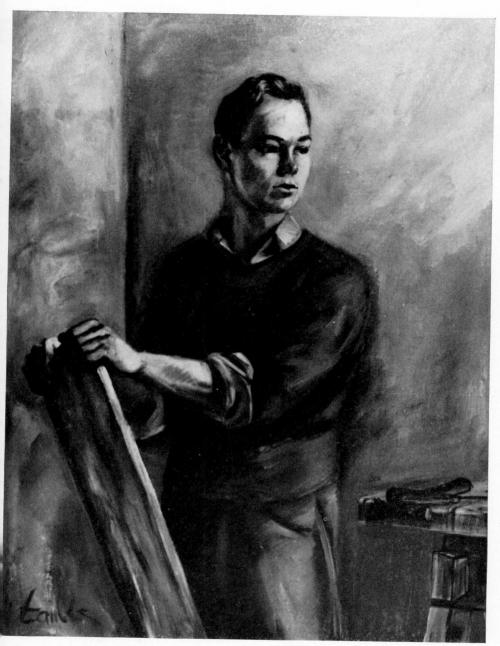

FRANK. A portrait completed at one sitting. The canvas of this typical alla prima painting carried a burnt sienna imprimatura on a light gray ground.

SAINT JOHN ON PATMOS.

On this and the following page are renderings which led up to the final oil painting reproduced on page 60 and described on page 63.

SAINT JOHN ON PATMOS

SAINT JOHN ON PATMOS.

At left is shown the under-painting. Below is the finished picture.

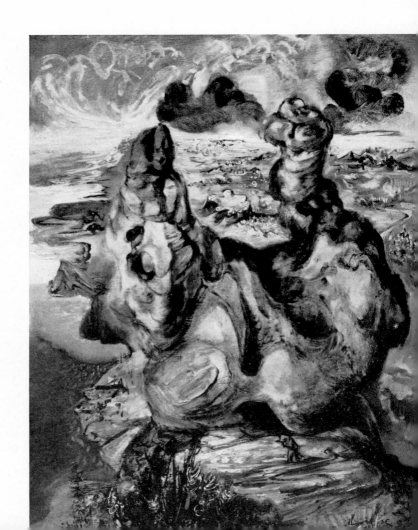

PAINTING ON AN IMPRIMATURA GROUND

The imprimatura, which is a transparent film, layed over the umber-white ground in the illustration on page 46, was prepared with burnt sienna (right) and with viridian green (left). This imprimatura is produced in the following manner: the chosen color (as it comes from the tube) is diluted with Copal Varnish, *not* with the medium to the consistency of water color, and then painted thinly on top of the toned ground with a brush, or rubbed in with a rag or the hand, in short, in any conceivable manner, according to the painter's predilection. The imprimatura need not be evenly painted and uniform in appearance. It can be thicker and thinner in places, depending on the occasion. At any rate, Copal Varnish is the only suitable medium for this particular purpose. An oil containing diluent (such as our painting medium) would be entirely inappropriate because it is too fat and a damar varnish imprimatura is also unsuitable because it would dissolve under the action of the painting medium applied on top of it. Even a well-dried imprimatura film prepared with damar varnish will not be resistant enough, for the turpentine which our painting medium contains will act upon it and dissolve it in short order. Copal Varnish, on the other hand, solidifies after a short time to such a degree as to become impervious to the action of a solvent such as turpentine. However, a harsh, forcible rubbing of the painting medium onto even a copal imprimatura should be avoided.

To return to the painting on page 46 (right) it proceeded in the following manner: the drawing was made directly on the imprimatura (moistened with the medium)* with a small round sable brush using umber color considerably thinned with the medium. For the shadows, umber, light red, and ochre were used. The lights were painted with white and ochre without pronounced impasto and little blending was attempted since the underlying imprimatura, which remains visible in many places, mediates most effectively between the light and shade of the figure. The figure on the pink ground has a viridian imprimatura and is painted in umber, ochre, ultramarine, and white. (For further notes about imprimatura see page 70, under Still-Life Painting.)

The painting of both these figures took about twenty minutes. Of course, one must be fairly sure of one's drawing to work without much faltering. This all sounds as though painting as described above is extremely simple and the method easy to follow. In fact, it is just as simple as it sounds. There are ways and means of making

* The imprimatura was completely dry before the medium was applied.

oil-painting technique a relatively simple discipline, but there are no short cuts to draftsmanship. This can be acquired, according to my own experience, only in the hard way—by constant practice and devotion.

To return to our figure painting, it must be considered, in spite of the preliminaries such as the toned ground and the imprimatura, as alla prima painting, because it does not carry any overpaints. In other words, the final effect has been aimed at from the start with the intention of finishing the work while painting wet into wet. It must, however, be conceded that even the most expert hand may flounder at times and that corrections will have to be done later on, on the surface of the dried painting (see page 71). Although such an emergency may frequently appear, nevertheless the method of procedure from the very start must be considered as alla prima.

As regards imprimatura, it need not be made up of one single color. As described in the notes on still-life painting (page 70), a multicolored imprimatura can cover the priming. But in case of figure painting, only a few colors will be used such as burnt sienna, ultramarine, umber, viridian green. They can be—after having been diluted with Copal Varnish—mixed together to produce a desired tonality.

It has been suggested once or twice in the book that an imprimatura is a glaze. This is so, but it is used *only* prior to painting, whereas a glaze in the true sense of the word is used during painting. Also, imprimatura is mixed with varnish which has no oil substance, but a glaze is mixed with the painting medium.

ALLA PRIMA PAINTING BY THE MASTERS

Alla prima painting can be observed particularly well in the work of Rubens, Degas, and Frans Hals. Although centuries apart, these paintings show a great similarity in technique. Rubens covered the white ground of his panels with a grayish-yellowish imprimatura, without benefit of a toned ground in the color example on page 66, at least. However, all sorts of toned grounds can be found in one or another work of this great painter. On the rather streaky and spotty imprimatura the painting on page 66 was done swiftly in one sitting. The drawing was traced on top of the imprimatura. The latter is not entirely covered up by the painting and remains, as you can see, clearly discernible in many places on the panel.

Degas (page 67) liked to use an umber imprimatura. With this he often covered a rather dark ground. As a result, some of the paintings, despite their relatively young age (a painting even one hundred years old must be considered young), have darkened considerably.

Even when painted on a white canvas, a dense and dark imprimatura will adversely influence a thinly executed subsequent painting.

Frans Hals used also an umber imprimatura. Over this he executed his alla prima painting with large brushes in swift, bold strokes in what appears to have been a matter of minutes. The dexterity of Frans Hals' hand is, of course, unique. (See page 65.)

THE BORDERLINE BETWEEN ALLA PRIMA AND UNDERPAINTING

On pages 58 to 60 the progress on my painting *St. John on Patmos* can be traced. The top illustration on page 59 shows what might be called an inspired doodle. In doing it, so it seems, I had in mind shapes of some fantastic rock formations. The swirling, cloudlike shapes suggest an apparition rather than a motif seen in nature, but they lend to the landscape an evocative, supernal mood. To retain the authenticity of the idea (for this is essential if you wish to communicate your thoughts and feelings to your fellow man) you have to go back to nature for reference.

One of the references in *St. John* was a piece of sandstone, two studies of which are seen at center of page 59. After I familiarized myself with the factual appearance of the stones, the forms were conditioned to respond to the mood in which the saint might have received his revelations. Also, the size relations experienced a radical revision. The more the grandiose and apocalyptic in nature developed, the smaller became the figure of the saint. So much for the genesis of the composition and its iconography.

As for the technicalities, on page 60 the underpainting of the picture is demonstrated. Now, the term underpainting has scarcely been used in this book, since my intention is to deal here primarily with alla prima painting. The term underpainting at once implies that multicolored, preliminary effects executed in solid, opaque paint underlie the final painting which is done at more than one sitting. *St. John* is, indeed, not painted on a uniformly toned ground, but it received a dull, neutrally colored underpainting, ranging from a pale yellow (ochre and white) to a light gray (umber, prussian blue, and white) and light green (prussian blue, ochre, white). Since this constituted only a slight modification of the toned ground, and since the painting (33 x 40 inches in size) was painted in one single sitting (about eight hours), and no overpaintings at all were done, it may be looked upon, perhaps, as a "border case"—not quite alla prima, not elaborately underpainted.

And now a word about the principles of underpainting for those interested in this method.

UNDERPAINTING (Oil Painting at More Than One Sitting)

Here the white canvas ground is first coated with a more or less neutral paint, composed chiefly of white lead (flake white) with a chosen color added. Certain textural definitions and outlines, important in the final effect, should be done in this first layer of paint.

As a rule, a second underpainting is then applied* to increase the effect of texture and to strengthen the color in areas where one expects later to use glazes (see page 71). It is of utmost importance to consider well these colored passages of the underpainting, so as to make the superimposed, transparent color as effective and brilliant as the materials allow. Keep underpainting colors light and opaque.

As regards the color problem, one or two underpaintings will suffice, but if one wishes to produce strong textural variations, the paint will have to be built up in three or four layers, sometimes even more. Take the precaution of increasing the amount of oil in the upper layer, always observing the principle of painting fat on lean.

LANDSCAPE PAINTING FROM NATURE

When you paint landscapes from nature, the toned ground, described earlier, is not desirable because it would almost inevitably lower the coloristic effect of the painting, except in cases where heavy, opaque paint layers are used. But a *toned ground of a yellowish color* will be quite suitable, for a yellow color will spur the greens on top of it to livelier action and will also lend a certain radiance to the blue of the skies. However, it is important to keep this yellow color light and in a low key (ochre and white), for it has been my experience that a strong yellow tone influences the choice of colors and can easily throw the entire color scheme out of kilter.

When painting out of doors (which, as a rule, induces a sketchy approach), one can very well use a white canvas ground. But this canvas must be rather smooth, so as not to impede the painter's progress and defer his statements. A coarse grain would voraciously absorb a great deal of paint—and efforts to apply it—and brushing masses of wet paint together always invites messy conditions.

Underpainting, when working out of doors, is a rather involved proposition. It is first necessary to make a drawing directly from nature. Then you can underpaint on location or at home (color notes are all one would require for this purpose). Waiting for the underpainting to dry is the next phase, and this may take three days, a week, or perhaps longer, all depending on the nature of the color used and the thickness of the paint stratum. It is obvious in outdoor painting, then, that a white or light yellowish ground is logical.

* Always wait for the underpainting to dry.

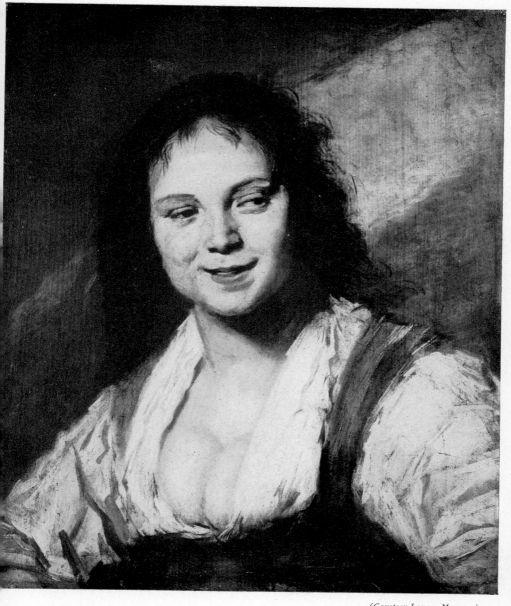

THE BOHEMIAN by Frans Hals (1580-1666). An alla prima painting on an umber imprimatura. Hals was a master of portraiture done at one sitting.

THE TRIUMPHAL ENTRY OF HENRY IVth INTO PARIS (Detail). By Peter Paul Rubens (1577-1640). An alla prima painting on a streaky gray and ochreish imprimatura. (See page 62.)

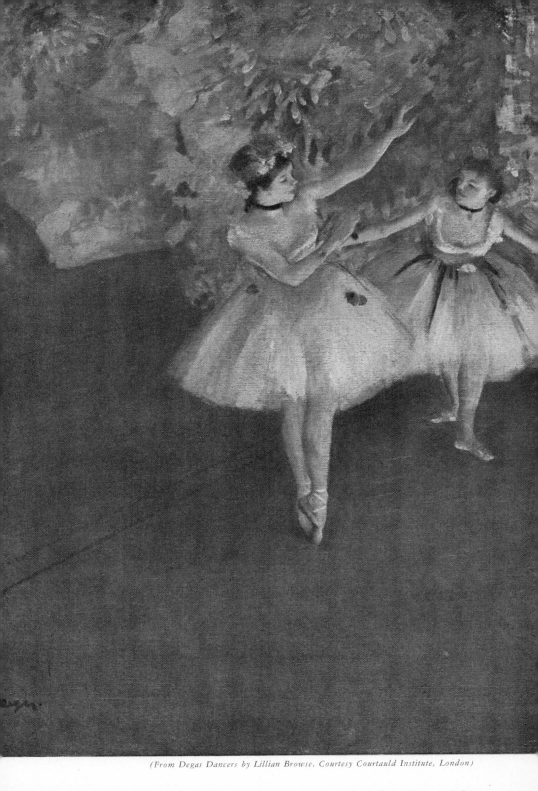

LE PAS DE DEUX SUR LA SCENE, by Hillaire Germain Edgar Degas (1834-1917). An alla prima painting executed on an umber imprimatura. (See page 62.)

Above: In a composition of this nature the background (that is, the sky) should be painted first. See discussion at bottom of opposite page.

Right: Sketch demonstrating superimposition of flowers on top of the finished background. See notes on page 71.

Above: Color scheme for underpainting as discussed on page 70.

Right: Contrasting colors which would be painted over those shown in the illustration above.

The palette to be used in landscape painting was thoroughly discussed in Chapter V as well as the behavior of colors in space. As to the construction of a landscape composition, a few cardinal principles should be kept in mind: (1) That of the foreground, middle ground, and background, and their coordination into a unifying design. This does not imply that all the landscapes must necessarily show these three distinct planes. A foreground motif alone might do, or perhaps you will omit the foreground and consider only the middle ground and the distant plane. (2) The relations of the sky area to the ground area, that is, the placement of the horizon. A low horizon will allow a large surface to be used for the sky, and a reverse situation will suggest a bird's-eye view. (3) Distribution of light areas and those kept in shade. The problem of orchestrating the lights in a painting and playing them against the darks often accounts for the success or failure of a painting. There are no set rules here that would help the painter to arrive at a just solution, except for one general principle which it is well to remember: Make your light and shade pattern varied—avoid monotony!

If a landscape painter cannot procure the right grade of canvas, that is, one with just the proper grain, he can improve even the poorest material simply by applying a new white lead (flake white) ground with a palette knife. Painting on such a ground can contribute a great deal to the success of a picture. As described in Chapter I, white lead used for this purpose can be of the grade sold in cans. It should be thinned with Copal Varnish. Some cobalt dryer can also be added to accelerate drying. The importance of this new ground cannot be overemphasized, for besides improving a poor canvas, it will impart its own texture to the painting.

As I stated previously, after the canvas ground dries, it should be moistened with the medium at the time further work begins. I must add that it has been my invariable experience that whereas on a white lead ground the painting medium behaves beautifully, it does not seem to have much affinity for the commercial canvas grounds which are, as a rule, prepared from a different material.

Thus the canvas has been made ready. The next question is: Where shall we start to paint? Which particular object shall receive our first attention? The answer to this problem comes from practical experience: When the composition shows depth, it is logical to start first with the distant plane. Obviously, all objects in the foreground are superimposed upon the distant planes.

Take, for example, the illustration sketched here*, which can serve our purposes as the subject of a painting. If we paint the trees in the

* Opposite page, top.

foreground first, how are we to deal with the background? To paint it around these foreground objects would be awkward and involved. Hence it is logical, in such an instance, to paint the background first and the foreground last. When the problems discussed above do not apply, the first object to receive attention is the central object, the important one which dominates the composition and attracts our first attention. All the other objects in our composition will have to be attuned so as to complement the main motif to its best advantage. (For colors in landscape painting, see page 41.)

STILL-LIFE PAINTING

Here, too, the use of a dull-colored toned ground such as we know it in portrait painting is even more inadvisable than in landscape painting, for it lacks the luminosity that would aid us when painting the brilliant objects. On the other hand, a bright yellowish ground (ochre with white) will serve our purpose well, and also a white or a *very* light gray ground can be used to advantage, especially when conditioned with a multicolored imprimatura. This can be done in two different ways. The colors can be diluted with Copal Varnish to water-color consistency in the usual way, and as described on page 61, or the painting medium can be used for this purpose. In the first instance one can paint over the imprimatura as soon as it seems dry to the touch, that is, in about fifteen minutes. Of course, the imprimatura will still be too fresh to resist dissolving when acted upon by paints thinned with our medium. Its color may come off here and there, but this will not prove to be too great a handicap.

In the second method a glaze, rather than an imprimatura, is used. The glaze is prepared with oil colors thinned to the consistency of water color, not with the quickly drying Copal Varnish, but with the painting medium. Here one would paint into the wet glaze.

The application of the imprimatura (color diluted with varnish) or the glaze (color diluted with the medium) has the purpose of increasing the coloristic brilliance of the painting. To do this with greatest effectiveness, make the color scheme of the imprimatura contrast with that of the final, that is, the superimposed painting. An example of such a contrasting color scheme is demonstrated in the illustrations at the bottom of page 68.

It is important to observe that the colors of the imprimatura are well blended, that is, do not show distinct contours. In other words, soft transitions from one color to another will be required. Such precaution need not be taken when a glaze is applied to the canvas, for the wet, medium-thinned paints will, in the process of working, blend by themselves.

Painting flowers can be done on the white canvas, but because the white of the canvas is not suggestive of a background, and because painting of the background around the flowers would be awkward, it is practical to paint a preliminary background first. A palette knife is an excellent instrument for this purpose, for it will permit applications of thinnest paint layers, such as would not tend to interfere with the superimposed painting. The flower background problem is demonstrated in the sketch on page 68 which shows the limited areas in which a background would have to be worked were it not for the preliminary toned ground. (The colors in flower painting are discussed on page 50.)

CORRECTIONS ON FINISHED PAINTINGS

When parts of a dry painting, executed alla prima, require corrections, this can be done in the following fashion: All heavy impasto should be flattened with sandpaper, and the transparent, thin passages should be removed (or partially removed) with turpentine. (If they are quite old, the removal will not be simple and turpentine will not be effective. Benzine will prove to be a stronger and often effective solvent. However, I would not advise an inexperienced person to use some of the powerful solvents.) There is no need to erase completely the area to be overpainted. But, if a more or less transparent passage is to be used, a new underpainting will have to be created by simply laying it in on top, so as to cover up the original painting.

If one is planning to paint with impasto, before working on a sandpapered painting, it is sound practice to rub the area well with a rag moistened with turpentine and then to apply some of the Copal Painting Medium in the usual manner.

GLAZES

The difference between a glaze and the imprimatura ground was described on page 62. Glazes are used only in overpainting. The preparation of a glaze is made with the chosen oil color and the Copal Painting Medium (Light or Heavy), not with Copal Varnish as in imprimatura. The purpose of a glaze is to produce a complex color effect which results from superimposition of two colors, the first always light and opaque, the second (the one on top) always darker and transparent. In other words, a transparent color, which will reveal the lighter color from within, will be called a glaze. The "lighter" color can be white or any other relatively light color.

CHAPTER VII
STUDIO MODELS

The idea of using studio models for representation of landscape motifs is not new. Already in the fourteenth century Cennino Cennini advised painters to keep branches of trees and bushes, to serve as models for trees and forests, and pieces of rocks from which mountains could be painted. In my own practice I have found this ancient advice well worth following. The painter's studio should abound in all kinds of materials on which he can feed his imagination and which can serve him as a source of manifold information. It is of great importance that the painter familiarize himself with the objects, making sketches from them under different lighting conditions.

I have already called attention to the role that light and shade can play in the general scheme of a painting. To find just the right light conditions in a landscape is not easy. Moreover, the best lighting effects in nature have the most annoying habits of vanishing as soon as they have reached their dramatic climax. When you use studio models, the most dramatic light and shade effects can be made to last as long as required. An artificial source of light is always conveniently at hand, and such lighting can produce stronger and more interesting effects than daylight. The illustrations on pages 73 to 83 represent some of my studio models and studies made of them in black and white and in oil colors.

MANNEQUIN IN DIFFERENT POSES. (Original size, 16 inches.) Where figures are called for in unusual poses, a mannequin such as illustrated here becomes a useful part of your studio equipment.

A piece of driftwood found on the shore

DRIFTWOOD. The example opposite served as a model for the drawing below. This motif was used in a painting.

A piece of rock found by the roadside

ROCK. A drawing with a rock motif taken from the studio model photographed on the opposite page.

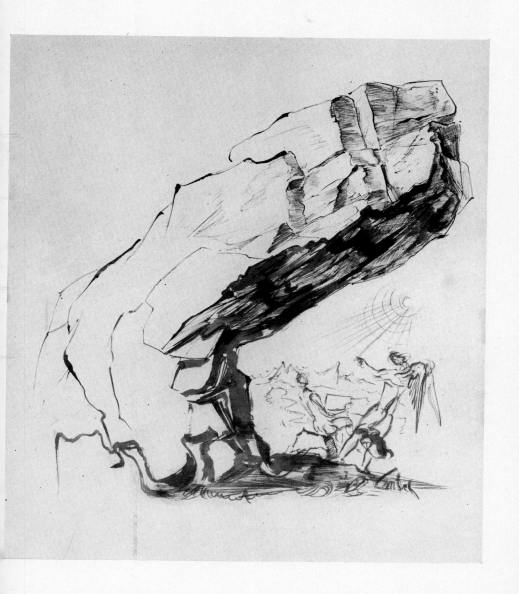

Miscellaneous objects used as studio models. *Above:* A piece of driftwood suggesting an animal. *Below:* A piece of rock suggesting a mountain.

A piece of bark used as a studio model.

AT THE SEA. A painting based on the coral and shell formations above.

THE GIGANTIC DRIFTWOOD. A painting suggested by the driftwood below.

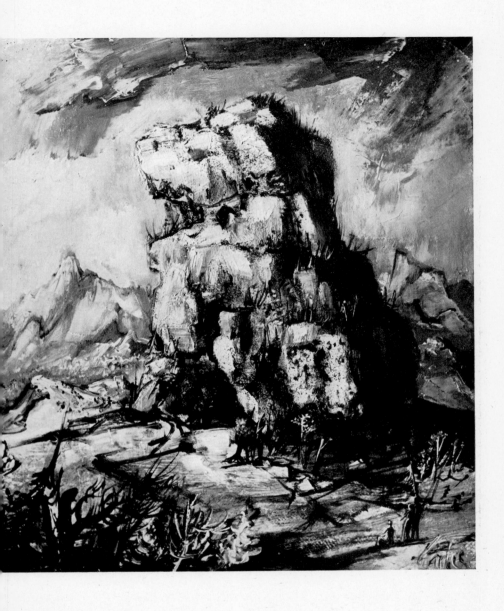

THE ROCK. The studio model in the photograph opposite formed the basic
theme of the painting above.

FRAMES. (See page 87.) The outside frame is in Finish No. 1, for wormy chest-
nut. The inside frame is in Finish No. 2, for metal leaf.

CHAPTER VIII
VARNISHING AND
CLEANING A PICTURE

VARNISHING

Upon completion, every painting should be varnished, first, to bring out its true colors; second, to protect it from dirt.

When I speak of "true colors," it must be understood that a dry paint film does not always show the same colors apparent when the painting was still wet. Colors which go flat lose their true values. The dark colors, especially, can lose all their depth, often to such a degree as to ruin the color value of the entire painting.

Flatness of color is always caused by the loss of oil in the top layer of the paint stratum. Some of the oil which binds the pigment may be absorbed by the priming of the underpainting, or it may move from the top stratum of the paint film and settle at the bottom. A flat appearance of the paint surface due to either of these actions can be remedied by the application of varnish.

The first varnishing can be done about a week after the completion of the painting. At that particular time the paint will still be soft, hence to prevent injury to the paint film, a flat sable brush should be used for varnishing, and not a bristle brush. The first varnishing should be done with retouching varnish which, as compared with damar picture varnish, has a lower resin concentration.

Varnishing should be done in systematic fashion, that is, only a small area should be covered at one time, and the painting should be held toward the light in such a way as to show clearly the spreading of the varnish over the surface of the picture. In other words, while varnishing one should be looking only at the gloss and not at the picture itself. It is not advisable to douse the painting with the varnish, hence the brush should not be loaded with it when working. A thin film of varnish will dry in a matter of minutes. It may, however, retain a slight "tack" for a while.

On a fresh painting, varnish will not always produce a uniformly shiny surface. In such a case, it is, as a rule, useless to repeat the varnishing in an effort to produce an even gloss. In any event, retouching varnish will not last on a fresh painting; after a few months it will disintegrate. At this time, however, the painting should be ready for a second coat of varnish. The paint film will perhaps have

solidified sufficiently to retain the new coat for a period of a year. Retouching varnish and a stiff brush can be used for this second varnishing. Depending on climatic conditions and the dust which may have settled on the picture's surface, even the second varnish will, in time, lose its luster and perhaps become discolored.

After a painting has dried well enough—that is, in about one, two, or three years, depending on the thickness of the paint stratum—you can apply a heavier coat of damar picture varnish that will not be adversely affected by outside conditions. First it will be necessary to remove the old varnish film and the dirt attached to it.

CLEANING AND PICTURE PRESERVATION

To clean a picture properly, first wipe off the surface dirt with a soft cloth. Then rub the surface gently with a wad of cotton moistened with picture-cleaning medium (the formula I use is also made up by Permanent Pigments of Cincinnati). Although this medium has a relatively low solving power, hard and prolonged rubbing on a thin paint application, and especially on glazes, should be avoided. Go at it gently. Glazes, especially those produced with damar varnish, are most vulnerable, regardless of their age.

After the varnish has been removed, the painting should be permitted to dry overnight. That means that the cleaning medium should be given time to evaporate not only from the paint surface but also from the linen, into which it sometimes penetrates through minute openings in the paint film. If the picture is revarnished prematurely, the evaporating solvent would impair the cohesion of the varnish film.

The damar picture varnish is applied in the same manner as the retouching varnish. The heavier varnish will produce a higher gloss on a painting, but in time the gloss will diminish, all depending on climatic conditions. The worst enemy of the varnish is steam heat, which can destroy the cohesiveness of the varnish. But, even under most favorable climatic conditions, atmospheric dirt (especially tobacco smoke!) will muddy up the originally colorless varnish film.

*Bead motifs
for frames
(see opposite)*

CHAPTER IX
FINISHING FRAMES

(NEW SUGGESTIONS FOR WOOD TREATMENT BY DONALD PIERCE)

In previous writings, I have described several methods of finishing frames in gesso, methods which I developed in the course of my own workshop experiments. In the meantime, my assistant and associate of many years, Mr. Donald Pierce, has also developed some new and excellent ideas on this subject, a few of which I would like him to present to the reader in this chapter. Mr. Pierce's suggestions augment those of my own, published some years ago in my book *Studio Secrets*. F. T.

MATERIALS NEEDED FOR FINISHING FRAMES

White casein paint
Red, yellow, blue, and black casein toners
Umber and black oil colors
Orange and white shellac
Several small pans for mixing
Several two-inch house-painter's brushes

Quick drying size for gilding
Silver leaf, gold leaf
Rottenstone
Liquid and paste wax
Wood rasp
Awl or ice pick
Alcohol torch or bunsen burner
Sandpaper, wire brush, steel wool

GENERAL OBSERVATIONS

The good working properties of commercial white casein paint, commonly sold in all paint stores, have achieved preference over homemade gesso as a material for finishing frames. The preparation of glue-and-whiting gesso is somewhat troublesome and there is also the necessity for keeping it warm while working. This is eliminated in the commercial white casein paint.

Patina is the workshop term applied to the unifying all-over gray casein wash. A mixture of raw umber and white produces the best gray color. This may be varied by a slight addition of yellow ochre, black, or burnt sienna.

Very effective ornamentation of simple wooden frames can be achieved by the use of commercial decorative moldings (see illustration opposite). They come in a variety of bead motifs to be glued to the frame and finished in the usual manner of carvings, as will be described later in this chapter.

⨯⨯⨯⨯⨯⨯⨯⨯	Scratching
∴∵∴∵∴∵	Grey Casein
⫻⫻⫻⫻⫻⫻	Umber & Black Oil Color

Finish No. 1 for wormy chestnut or oak frames.

FRAMES OF WORMY CHESTNUT, OAK, OR ANY COARSE-GRAINED WOOD

Finish No. 1. (See illustration above and photograph, page 84.) The first operation for all raw wood frames is to round off and blunt the four outside corners with a wood rasp.

After any desired carving has been done, the entire face of the molding is vigorously scribed with an awl or an ice pick. There should be many scratches and grooves running lengthwise, parallel to the grain of the wood. This accentuation of the grain helps to simulate actual weathering of the wood. Care should be taken to stop the scribed lines at the precise end of each mitered piece, to avoid a right-angle cross-hatch in the corners.

The whole frame is then painted with a thin coat of neutral gray casein. This patina should be of a light color. The tint should be composed of raw umber and white with a very small addition of ochre and burnt sienna, then thinned with water to milk consistency. Apply this gray liberally, making sure to get it well spread and down into all depressions in the corners, carvings, etc. Before this patina is dry, it should be wiped off with a cloth, thus exposing the raw wood, especially on the raised protuberances of the molding.

When the patina is dry, a dark brown oil color (mixture of umber and black) of tube consistency is taken up on a piece of cloth

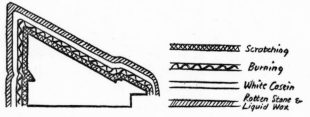

⨯⨯⨯⨯⨯⨯⨯⨯	Scratching
∧∧∧∧∧∧	Burning
———	White Casein
⫻⫻⫻⫻⫻⫻	Rotten Stone & Liquid Wax

Finish No. 2 for wormy chestnut or oak frames.

88

wrapped around the index finger and rubbed very slightly in a streaked fashion over the frame. These dark accents should be very subtle and not overdone. By very lightly touching just the topmost surface of the raised grain, the effect of the texture is beautifully brought out. The flat mat effect of this finish is very agreeable, but the outside edge of the frame and the carving may be slightly waxed with paste wax.

Finish No. 2. (See illustration page 88, photograph, page 93.) After the outside corners have been rounded off with the rasp, and again after any desired carving has been done, the entire frame is scratched vigorously with an ice pick or a sharpened nail, as described in finish No. 1. The frame is then further textured by brushing briskly with the grain, using a stiff wire brush. This imparts a beautiful weathered effect. Next the frame is toned by singeing the wood with the flame of an alcohol torch or a bunsen burner. A streaked, uneven tonality from light to dark brown should be produced by this toning treatment. The frame is liberally coated with white casein paint of normal consistency. Make sure that the white is painted well down into all the depressions, then, before it dries, wipe it off with a cloth. Light sanding with No. oo sandpaper may follow when the white has dried. The frame is then ready for the final coating of the gray patina, which is composed of Rottenstone mixed with liquid wax. About ten minutes after applying it, this coating is wiped off, and shortly thereafter the wood is polished with a soft cloth.

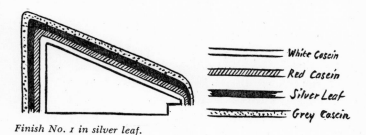

Finish No. *1* in silver leaf.

FRAMES FINISHED IN SILVER OR METAL LEAF

Finish No. 1 in silver leaf. (See illustration above and photograph, page 93.) A frame made of basswood or poplar is best suited for this type of finish. After the usual rounding off of the outside corners, and after any carving has been done, the entire face and the sides

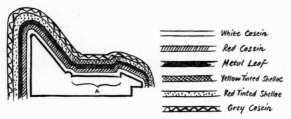

	White Casein
	Red Casein
	Metal Leaf
	Yellow Tinted Shellac
	Red Tinted Shellac
	Grey Casein

Finish No. 2 in metal leaf.

of the frame are built up with at least two heavy coats of white casein. After sanding, the entire frame is painted with a heavy coat of burnt sienna or venetian red casein. This coat is also sanded smooth. Some streaky smears of ultramarine and ochre can be painted on top of the red and then sanded smooth to prevent the subsequent coat of size from being absorbed.

The frame is now ready for a coat of shellac. When the shellac is dry, give the frame a thin, even coat of a quick-drying size. (This size can be purchased in any paint store, or it can be prepared by adding five drops of cobalt siccative to a tablespoonful of any commercial floor varnish.) When the size is almost dry, but still somewhat tacky, the frame is ready for gilding. For this finish use genuine silver leaf. To lay the leaf, pick up the open book with the thumb on top and the index finger underneath. Beginning at the outside edge of the frame, apply the leaf by bending the book slowly forward until the leaf covers the frame. Now, with a soft cotton tampon, press the leaf down into all the depressions, etc. Let the next leaf cover and overlap the first about one-quarter inch and proceed thus until the entire frame is covered.

There will certainly remain small areas exposing the color underneath. These must be covered immediately with small scrap pieces of silver leaf. To smooth off all the ragged, excess silver, rub gently with a cotton tampon. The next step is to ameliorate the raw, bright silver color by tarnishing it, thus giving a mellow, antique appearance to the finish. The tarnishing can be arrived at by natural oxidation, that is, by waiting several weeks, when exposure to the air will have tarnished the silver. However, to save time, this can be done by lightly sprinkling the frame with powdered sulphur. The process must be watched and checked at intervals of up to one hour. When the proper degree of tarnishing has been reached, the frame will take on an exotic, purplish-gray patina that is very beautiful. At this point it is necessary immediately to stop the oxidizing process by dusting off the sulphur and sealing off the surface with a coat of

shellac or banana oil. When this is dry, the frame is given a thin wash of neutral gray casein paint which is wiped off with a rag before it is thoroughly dry.

The gray paint should be left in the depressions only. Finally, the frame is waxed and then spattered. The spattering is done by dipping a toothbrush into black casein paint and rubbing the brush over the edge of a knife blade. Make a test first on a piece of paper to determine the size of the spatter. Then proceed to spatter the frame.

Finish No. 2 in metal leaf. (See page 84, also 90, top). This is a beautiful antique, two-toned metallic finish for certain moldings of basswood. It is appropriate on a molding the design of which has distinctly separate surfaces. Also it is excellent on a simple flat molding upon which can be drawn a decorative geometric repeat design.

Prepare the frame with two heavy coats of white casein and one of venetian red or burnt sienna and sand it smooth as in finish No. 1. Next gild the frame, as described above. For this finish, however, one may use silver or gold metal leaf.

When the excess leaf is cleaned off and polished with the cotton tampon, and after the size has thoroughly hardened underneath, the frame is very lightly rubbed with steel wool, breaking through the leaf in a soft, streaked fashion, exposing the color underneath. Part of the frame is then shellacked with orange shellac or tinted with gamboge or hansa yellow; the other part is coated with orange shellac, tinted with alizarin crimson or burnt sienna.

A repeat decoration* is traced on the gilded frame and the design is shellacked with one of the above tints. The background and the outside of the frame are shellacked with the other tint. This decorative pattern should be made of simple squares, circles, diamonds, etc. To tint the orange shellac, first moisten a little dry pigment with alcohol. Then incorporate it with the shellac. When the shellac is dry, proceed with the regular gray casein wash applied on top of the leaf, wiping it off with a cloth before it is dry.

The last step is to wax and polish the frame with paste wax and then spatter it with black, as described in metal finish No. 1.

* See borders on this page.

RESUME OF THE BOOK

If you are about to paint in oils and have never attempted this before, the following are the successive steps to be followed for the alla prima technique—the completion of a painting at one sitting. (For a list of materials and equipment see Chapter I.)

(1) Buy canvases already stretched and primed (or, of course, you can, if you wish, stretch, size, and prime them yourself). You can paint on the ready prepared canvases without any additional priming but for better results prime them again as recommended in Chapter I, or:

(2) Prepare toned ground in a solid light color (see page 15, and color illustrations, pages 46 and 47). Use gray-brown ground (raw umber and white) for portraits; use pink ground (venetian red and white) for figures. Use white or pale yellow ground (ochre and white) for landscapes and still lifes. For the latter, a multicolored imprimatura base can be used instead of a toned ground (see page 61). Allow to dry.

(3) Sketch your figures, landscape, flowers, etc., in charcoal over the prepared ground described above.

(4) Fix charcoal with fixitive so that it will not rub off (or you can paint the outlines of your sketch with an oil color greatly thinned with turpentine). See page 55.

(5) Apply medium (see Chapter III) to canvas, then mix paint with medium to desired consistency on your palette. Apply paint to the canvas with bristle brush and start work. Later, for blending colors, use sable or soft-haired blender (see Chapter II). N.B.: Wipe brush clean with rag before starting with each new color.

(6) See notes on colors to use for flesh tints, portraits, flowers, landscapes, etc., in Chapter V.

(7) When you finish painting, wipe brushes on newspaper or paper towel as clean as you can, then use soap and water for final cleaning.

(8) Leave painting, or store it away safely so that nothing can touch it until dry. In a temperature of 70 degrees, the painting will dry in about one to three days, depending on the nature of colors and thickness of paint stratum.

(9) Varnish painting (see Chapter VIII) and frame (see Chapter IX).

N.B.: Oil paintings can be overpainted if not satisfactory. See page 71 for notes on corrections on finished paintings.

FRAMES. (See page 87.) The outside frame is in finish No. 1, for silver leaf. The inside frame is in Finish No. 2, for wormy chestnut. (See also page 84.)

Opposite page: THE CHRISTMAS TREE. *Above:* SODOM & GOMORRAH.

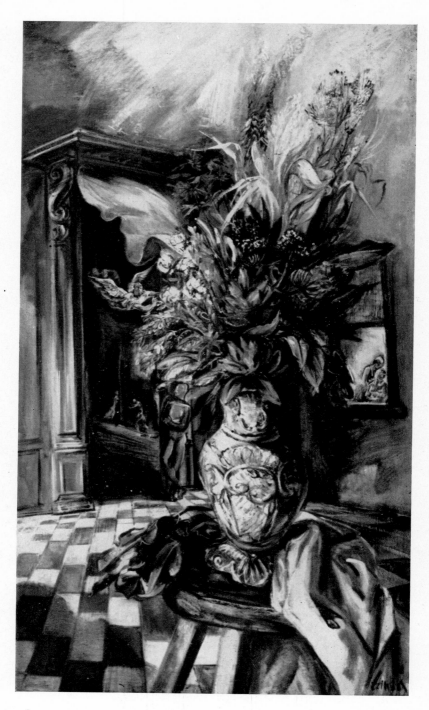

Opposite page: VICTORIAN VASE. *Above:* AT THE WINDOW.

Above: HEAD WITH VEIL. *Opposite:* GIRL WITH FINCH.

VENUS
WITH
WINGS